PAULA REGO

CRIVELLI'S GARDEN

PAULA REGO

CRIVELLI'S GARDEN

NATIONAL GALLERY GLOBAL, LONDON
DISTRIBUTED BY YALE UNIVERSITY PRESS

PRIYESH MISTRY
WITH A SHORT STORY BY CHLOE ARIDJIS

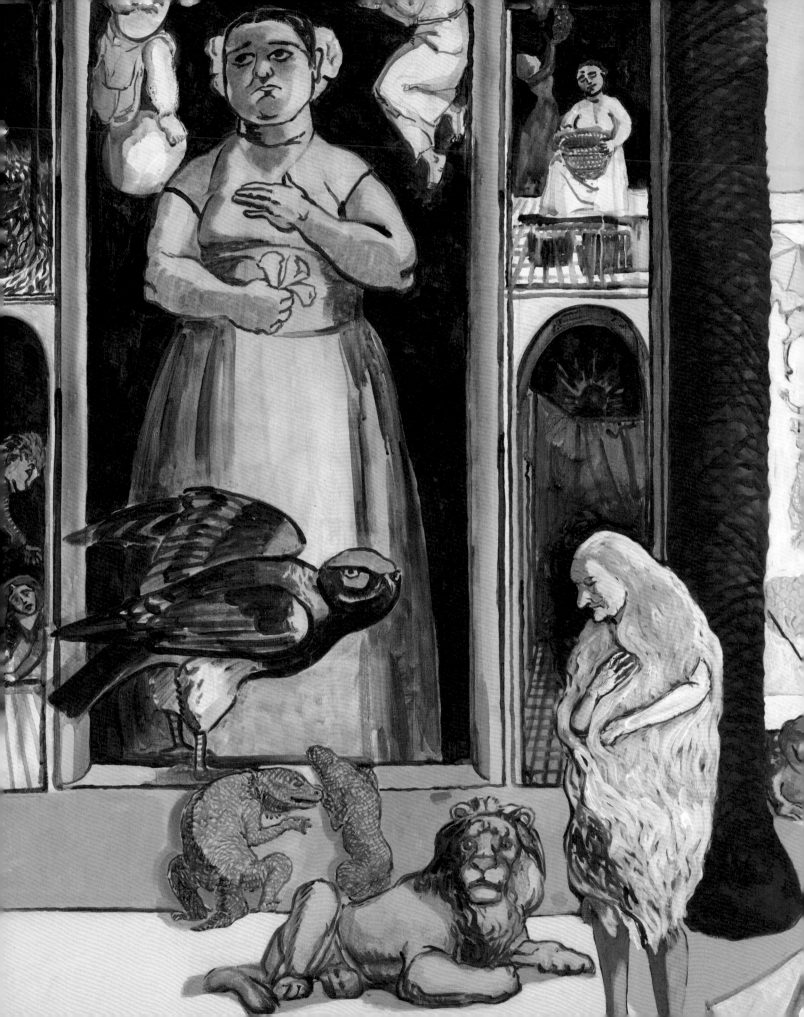

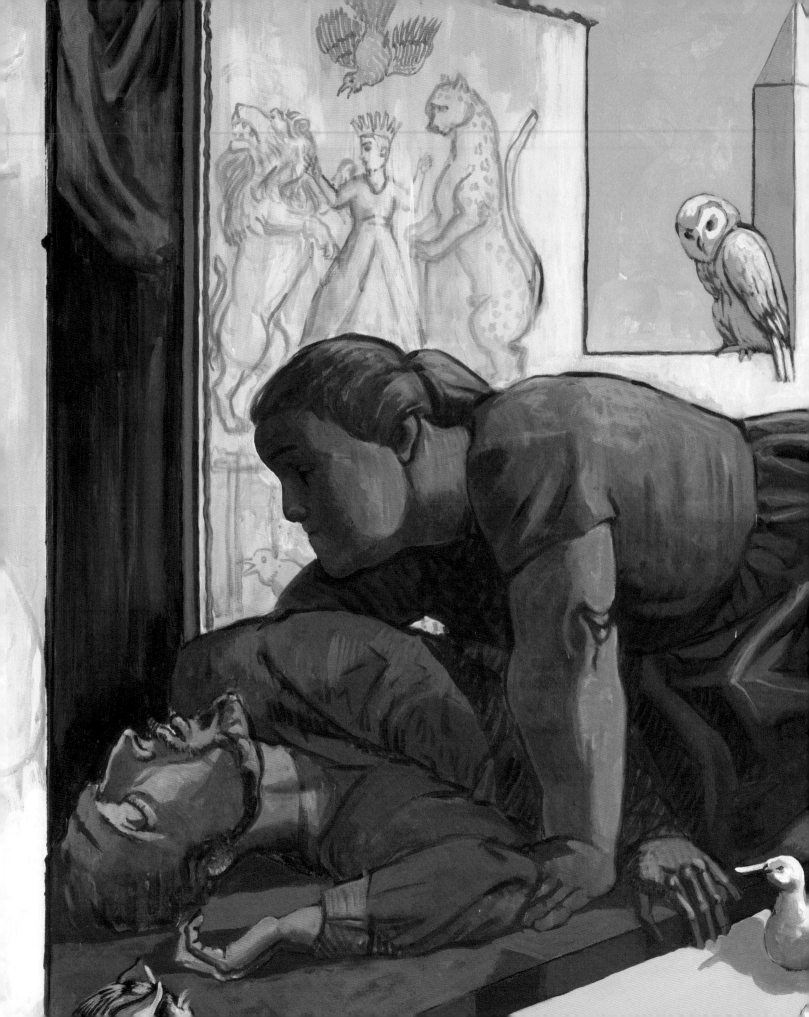

DIRECTOR'S FOREWORD
GABRIELE FINALDI

Paula Rego painted *Crivelli's Garden* over 30 years ago during her time as the National Gallery's first Associate Artist. Joyous in its high-key blue and white tones, it brims with lively narratives, some of them straightforwardly illustrative and others – as the artist has led us to expect – darkly sinister. It is a work rich in allusions to the Italian Renaissance paintings that had very recently been hung in the beautiful daylit galleries of the new Sainsbury Wing designed by Robert Venturi and Denise Scott-Brown and opened to the public in July 1991. *Crivelli's Garden* hung in the first-floor restaurant, which, for a time, took the name of the painting. Rego's work became an attraction in its own right, many people thinking it was a mural decoration when in fact it is a series of canvases more than 9 m in length.

By the time Paula Rego became Associate Artist in 1990 she had been visiting the Gallery fairly assiduously for nearly four decades, ever since she arrived in England from her native Portugal. She described herself as feeling uncomfortable with the old masters, but when she took up residence in the studio on the ground floor of the Wilkins Building, her initial ambivalence regarding the invitation overcome, there began a remarkably fertile engagement with the paintings in the collection and also with the Gallery staff, several of whom ended up featuring in *Crivelli's Garden*.

Carlo Crivelli, a fifteenth-century artist who was exiled from Venice and worked in the Marches in central Italy, is supremely well represented in the National Gallery. His sharply delineated figures, his quirky imagery and his powerful storytelling clearly fascinated Rego. In her 'garden', a syncretistic wonderland of myth, fable, religion and reality, Rego pays homage to Crivelli and to the Gallery's Renaissance masters, but she appropriates and distorts them, imagining them anew. Her storytelling, like Crivelli's, is distinctive and unmistakable.

This exhibition has been conceived by Priyesh Mistry, the Gallery's Associate Curator for Modern and Contemporary Projects. He invited the author Chloe Aridjis to write a short story in response to *Crivelli's Garden* and I am grateful for her striking contribution to this publication. Our thanks go also to those who have lent their works of art. The exhibition is generously supported by the Capricorn Foundation, in memory of Mr H J Hyams. I would also like to thank Aarti Lohia and the SP Lohia Foundation as the Leading Philanthropic Supporter of the National Gallery's Modern and Contemporary Programme, and we are grateful, too, for the sponsorship of Hiscox, Contemporary Art Partner of the National Gallery.

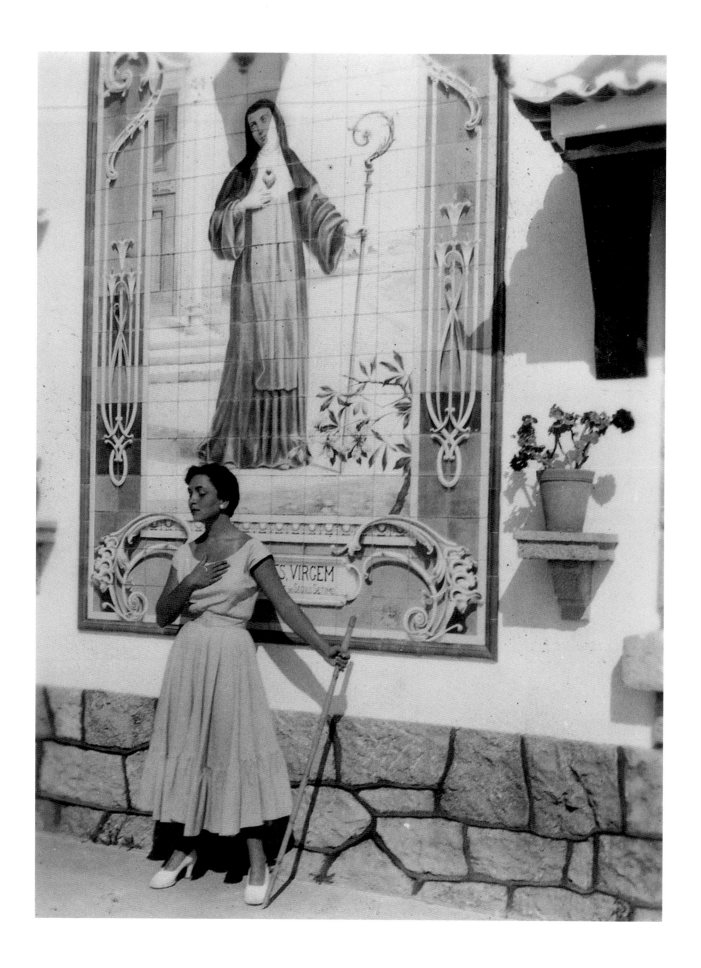

PREFACE
NICK WILLING

When my mother, Paula Rego, was 17 and at the Slade School of Fine Art in London, she would often visit the National Gallery and, in particular, stare at *The Rape of the Sabine Women* by Rubens or Uccello's *The Battle of San Romano*. Then she'd buy a family-sized 'brick' of Lyons ice cream and sit in a double bill at Leicester Square Odeon, to watch *Ivanhoe* perhaps or *Tarzan's Savage Fury*. The moving pictures of 1952, like their historical counterparts in the National Gallery, were made almost exclusively by men and reflected the male experience. For my mother, having been brought up in the fascist dictatorship of Portugal's Salazar, there could be no doubt that the world was controlled by a patriarchy. But then she would steal back to the Slade and make pictures that only she, a woman, could make, whether they were appreciated or not.

When she became the Associate Artist at the National Gallery we joked that she was back in the belly of the beast. The art world of 1990 hadn't changed much from that of 1952; it was still dominated by men. I remember my mother being told more than once that a great male artist could paint the female experience as well as, if not better than, a woman. But at the National Gallery Paula found a different way of looking at the world that was uniquely her own, in a voice that could only come from a woman. In 1965 her husband, Victor Willing, said that her pictures were like animals that she teased, humiliated, gouged, pitied and then hung trapped, broken, groomed and pampered on the wall. In 1990 her animals were more mature, more nuanced, but just as provocative. Like St Margaret, Paula erupted out from the belly of the beast stronger, with a series of pictures that showed she too was a master of painting, exploring themes that quietly challenged the patriarchy to examine itself. *Crivelli's Garden* was the last of those pictures: a celebration of female saints that sets aside the epic fanfare of Rubens or Uccello or countless other National Gallery painters to tell a different story of quiet assurance, defiance and survival. She was delighted to hang it in the National Gallery's restaurant because, as she put it, for her the only way into making the picture was through the back door, the kitchen door. When I told my mother that it had been taken down from the restaurant, she smiled knowingly … but was delighted to know, before she died last year, that the piece was going to be the focal point of a National Gallery display.

A 17-year-old Paula in front of the blue-and-white tiled panel of St Gertrude on the wall of the family home in Ericeira, Portugal, 1952.

9

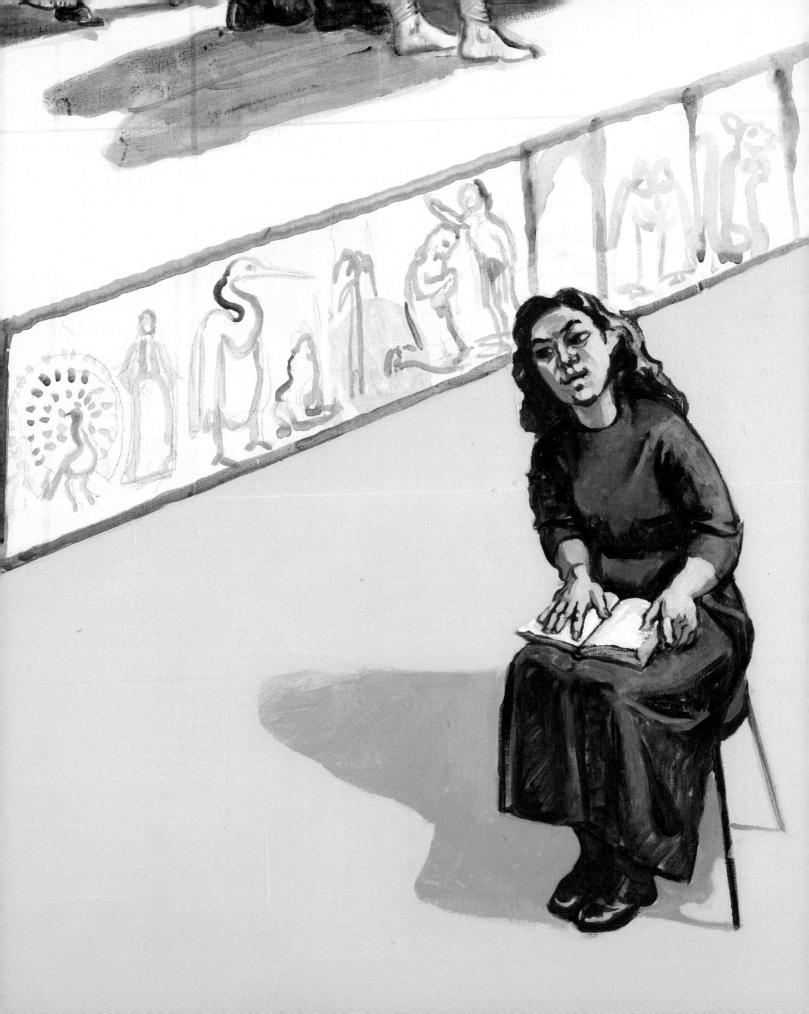

CHANGING THE STORY: PAULA REGO AND THE NATIONAL GALLERY

PRIYESH MISTRY

My favourite themes are power games and hierarchies. I always want to turn things on their heads, to upset the established order, to change heroines into idiots. If the story is 'given' I take liberties with it to make it conform to my own experiences, and to be outrageous. At the same time as loving the stories I want to undermine them, like wanting to harm the person you love.[1]

Paula Rego

In the lower right-hand corner of Paula Rego's *Crivelli's Garden* (1990–1), a young woman sits on a chair, her hands spread over an open book in her lap. It seems as if she is about to share a story, yet the pages in her book are blank, possibly waiting to be written in, or perhaps telling a tale that is not legible at first glance. She gazes sideways, her upper body leaning slightly to the left, as if gesturing to the viewer, her audience, to look at the rest of the monumental painting that continues across a panorama of three large panels. The painting expands to a labyrinthine walled garden of blue, white, brown and grey hues – a site that recedes to the distant sea on the horizon but also disappears around corners, behind pillars and extends off the edge of the canvas. Women occupy this maze-like space in the form of grand sculptures, some within friezes or atop fountains or plinths, while others, dwarfed by the scale of these mystical monuments, wander around their feet, walking, drawing, conversing or reading. Images of animals, men and other creatures are painted in blue on white walls, illustrating stories, perhaps moralistic murals, that are open to interpretation. What is clear is that many powerful exchanges are happening at once, some that are secretive or enchanting, others nurturing and welcoming. Layers of stories are locked in and waiting to be discovered, and in their revelations, our expectations overturned.

In an interview about *Crivelli's Garden*, Rego described the figure of the woman with the book as 'the reader' and 'the anchor figure' for the painting, a gesture towards her own continual engagement with literature, fairy tales and storytelling as important modes of communicating across time.[2]

The piece was commissioned for the National Gallery while Rego was its Associate Artist from 1990 to 1991. One of the largest paintings Rego produced, at over 9 m long, it represents many of the themes that occupied the artist before her residency at the Gallery and which continued to shape her work in subsequent decades. It was inspired by the paintings of the fifteenth-century Italian painter Carlo Crivelli (about 1430/5–about 1494) in the Gallery's collection, supplemented by stories of *The Golden Legend*, a thirteenth-century compilation of lives of the saints by Jacobus de Voragine. Rego was also influenced by the women that surrounded her throughout her life and during the residency. The painting presents a multitude of female saints and figures from across mythology within a garden, the walls of which are adorned with blue-and-white tiles characteristic of Rego's native Portugal. At once, she addresses the legacies of Catholicism and patriarchy that dominated her upbringing during the oppressive Salazar regime in Portugal (1933–68) and her early adult life whilst becoming an artist in London. Rego appropriates the various stories of fortitude found in ancient and folkloric narratives of these women to challenge the role of women within society and religion.

Growing up, Rego was surrounded with biblical stories from her Catholic upbringing as well as fairy tales recounted to her by her father, maternal grandmother and aunt. A grant from the Calouste Gulbenkian Foundation in 1976 allowed Rego to research and critically reflect on illustrations of fairy tales from around the world over a period of two years, culminating in a report that she used as a reference throughout her practice. Illustrations from Walt Disney animators and artists such as Gustave Doré were presented in two notebooks alongside her research into the origins of popular tales internationally.[3] She was versed in the fables that have been passed through generations of storytellers, remarking on the importance of them in her work: 'My paintings are stories, but they are not narratives in that they have no past or future. Everything happens in the present, incidents, daydreams, passions and consequences. They need characters and actions which evoke my feelings of fascination, fear and fun.'[4]

Rego saw the significance of how fairy tales can shape a person's sense of morality, particularly during childhood, and how they would often contain messages of virtue or ethical narratives played out by their protagonists. She was fascinated by the feelings such dark and brutal tales might evoke, acknowledging that their lessons may have conflicted with the lived experience of day-to-day life. In conflating such stories in her painting, without expressing a clear chronological narrative, Rego plays with such discrepancies. The art historian Ruth Rosengarten remarked that, rather than present a detached form of visual storytelling such as illustration, narrative for Rego 'is the provision of a containing environment where contradictions are held rather than suppressed, and where various versions of the self are enacted'.[5] Within the enigmatic scenarios that Rego depicts, multiple and divergent feelings and experiences are able to exist and be sustained without hierarchy.

The events leading to Rego's acceptance of the position of Associate Artist are indicative of this approach and her consequent engagement with the National Gallery and its collection. It prefigured a turning point in her practice that responded to and provoked the patriarchal tropes of the painting canon. Upon meeting Alistair Smith, Keeper of Education and Exhibitions at the Gallery, and Colin Wiggins, Curator and Rego's confidant during her residency, she turned down their invitation to be the first participant in the newly established programme. She declared that 'the National Gallery is a masculine collection and, as a woman, I can find nothing in there that would be of interest to me.'[6] Wiggins recalls that a week later he received a phone call from Rego asking if the position were still available. When he asked why, she cited the same impetus as before, this time stating: 'the National Gallery is a masculine collection and, as woman, I think I absolutely will be able to find things there for me.'[7] The opportunity to subvert the male gaze inherent to the history of painting was one too tantalising to resist, but the anecdote belies her hesitation in engaging with the celebrated painters of European history. In an interview about her perception of the Gallery, she spoke of her early discomfort when exploring the collection on visits while attending finishing school in the UK: 'I got a feeling of a kind of sinking-bowel syndrome whenever I looked at old masters. I felt uncomfortable.'[8] This mode of unease also became an incentive; throughout her career, Rego was recognised for her radical take on the dominant systems in society that were at the root of her discomfort. Rosengarten further observed of Rego's engagement with the old masters, 'her work began consciously to contend with, rather than contest, a version of the Western art-historical canon, with its conflation of patrimony and

artistic paternity',[9] and that any heritage received from European painting, a realm within which her work exists, is assumed to be of a male lineage.

When Rego was invited to participate in the programme, the Gallery's Sainsbury Wing was nearing the end of construction and Caryl Hubbard, a Trustee, suggested that Rego might design a backdrop for its new Dining Rooms. The commission was an addition to her brief for the residency, in which she had been invited to produce new artworks inspired by the collection for an exhibition. Rego had canvases prepared to the scale of the Dining Rooms' far wall but did not think about the restaurant's design scheme while producing them. She did, however, choose mainly placid colours so as not to distract from the restaurant setting and only came to see how well the work fitted, both in scale and aesthetic, once the panels were installed. She then added slim, column-like panels at either end of the panorama, since she felt the painting needed to be contained in some way.[10] The unveiling of the commission – which would hang in the Dining Rooms for the following 30 years – coincided with Rego's exhibition, *Tales from the National Gallery*, which was presented in the Sunley Room at the National Gallery between 13 December 1991 and 1 March 1992 during its tour of the UK.[11] The exhibition featured six paintings in acrylic and more than 30 works on paper, some of which were preparatory studies for *Crivelli's Garden*.

The concept behind the commission's meandering garden came after Rego saw the predella panel Crivelli painted for an altarpiece (fig. 1) for S. Francesco dei Zoccolanti, Matelica (a small town in the Marches, Italy), known as *La Madonna della Rondine (The Madonna of the Swallow)*; after 1490. The panel, which sits at the bottom of the altarpiece, is divided into scenes dedicated to the narratives of four different saints and the Nativity, all set within a semi-rural outdoor setting

with noticeable forms of architecture. Depictions of St Catherine and St George (shown with his sword raised to strike the disproportionately small dragon) flank the stories of St Jerome, the Nativity and St Sebastian. Each of these three central panels is depicted with an acute linear perspective; the landscape continuing in minute detail into the far distance. Upon viewing the panel while walking around the Gallery with Wiggins, Rego imagined that if she stepped into the painting through one scene and looked around the corner, she would encounter another scene of one of the other saints or perhaps a different painting by Crivelli altogether.[12] She imagined a world in which Crivelli's saints would co-exist and so decided to create her own version of the garden. The final labyrinthine structure of her fictional garden enabled her to complicate the viewing experience. By allowing the scenes to lead beyond the edges of the canvas, she invites her audience to question what else they may not be seeing and to consider what lies beyond the visible.

Rego based the aesthetic of the garden, and the seascape in the far distance, on her memories of her family home in Ericeira, a seaside town north of Lisbon, where she spent many summers as a child. She recalled how her bedroom walls were tiled floor-to-ceiling with arabesques in cobalt blue on white, that the drawing room was adorned with hunting scenes across the tiles, while the outside wall of the house had a tiled mural in the same blue-and-white style devoted to St Gertrude (page 8), the face of whom is thought to have been modelled on her grandmother.[13] As a pictorial device, the inclusion of tiled walls in Rego's painted garden allowed additional surfaces upon which to layer multiple narratives of female saints within the same site, and also connected the space to a location of great personal significance. On the advice of Erika Langmuir, then Head of Education, Rego turned to *The Golden Legend* to learn

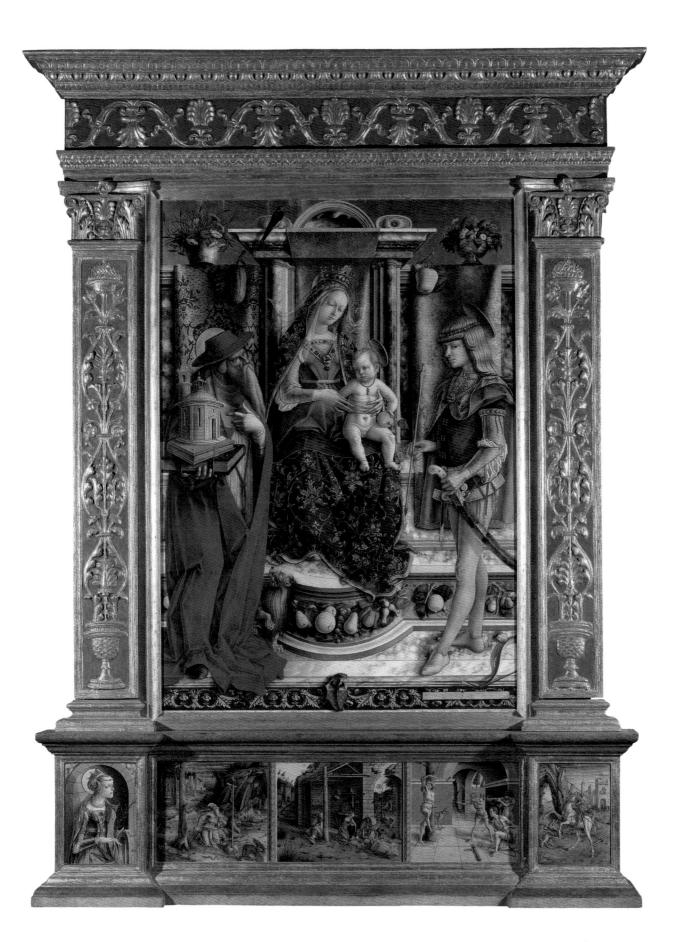

Fig. 2
Study for *Crivelli's Garden*, 1990
Ink and wash on paper,
29.5 × 42 cm
Courtesy Ostrich Arts Ltd

more about the lives of the Christian saints, an endeavour she found to be a remarkable way of responding to other artists across history: 'It was an exciting connection to find myself using the same book for the painting as so many great artists had used for theirs all those years ago – extraordinary really. So, it is a tribute in a way.'[14]

One of the first drawings that Rego made during the residency was dedicated to significant episodes from the life of the Virgin Mary (fig. 2). Scenes of the Marriage of the Virgin, the Nativity and the Death of the Virgin occupy different areas of the same built environment, recalling medieval techniques of depicting multiple narrative scenes within a single frame. This drawing ultimately became the basis for the large mural on the angled wall in the rightmost panel, behind two figures who seem to be conspiring. This is Rego's depiction of the Visitation, the event in which the pregnant Virgin Mary visited her cousin Elizabeth, who herself was pregnant with John the Baptist. Instead of eulogising this moment within the painting, Rego renders it almost ordinary. The women are turned in towards one another as if immersed in conspiratorial whispers. Elizabeth, painted monochromatically in brown, grasps the upper arm of Mary with one hand, while she shields her own mouth from the viewer with the other. The news that Mary is pregnant following the Annunciation becomes a private matter: a secret of concern shared between two relatives. Further complicating the linear timeline of the narrative, Elizabeth's young child, John the Baptist, features in the scene as a boy holding a lamb, while the image of Mary holding the baby Christ looms ominously out of the dark behind her as if a palimpsest on the wall.

This was not the first time that Rego had reinterpreted the story of Mary. In 1981, she made *The Annunciation* (fig. 3), a large painting with collaged elements,

after having seen one of Botticelli's Annunciations at the Uffizi Gallery in Florence. As John McEwen recounted in his biographic monograph of Rego's career, 'what had most impressed her about his Annunciation was the sense of awe, even terror, with which he had invested the moment when the young Virgin is informed by the archangel Gabriel that God has appointed her to bear His Son.'[15] Rego identifies the young Virgin Mary's sense of fear, not only in being confronted by the momentous task of having to carry a child, but also in facing a sacred messenger of God. The painting, typical of her collaged mode of work at the time, allowed Rego to present tensions that may not have been traditionally depicted. She fractures the protagonists, transforming Gabriel into an imposing form that towers over a cowering Mary, conveying her childlike fear among the overwhelming mass and confusion of pasted and painted shapes. As a recurring figure in her work, Rego transposes the trepidation of a young mother's painful labour onto the Virgin Mary's miraculous birth, an experience that is overlooked in the historic canon of representational and religious painting.

While the right-hand panel of *Crivelli's Garden* concentrates on the life of the Virgin Mary, the central panel is dedicated to a myriad of other female saints.[16] Focusing on the more obscure aspects of the saints' stories, the scene might appear domestic and ordinary at first glance, until small, uncanny details of their narratives begin to reveal themselves. Standing tall in white with broom in hand, St Martha's looming yet domestic presence first catches the viewer's attention. As she sweeps the floor, her sister Mary Magdalene sits and ponders in a voluminous black opera dress. The animated monument to St Catherine – who wields a sword overhead after decapitating a Roman emperor as vengeance for his ordering of her torture – stands prominently in the central panel.

So too does St Cecilia, set within a niche surrounded by the various episodes of her torments and accompanied by a hawk to symbolise her nobility. In the middle ground, in front of the niche, a smaller figure of St Mary of Egypt is shown shrouded in her own hair, which covers her nakedness. She is accompanied by the lion that eventually buried her in the desert, where she became a hermit after renouncing her life as a prostitute. Then, St Margaret appears around the corner. Her story, in which she was swallowed by the devil in the form of a dragon that she had befriended, is depicted on the wall behind her. She erupted from his stomach and became known thereafter as the patron saint of women in labour. In her hand she holds a leash that is tied to a large frog, Rego's rendition of the dragon demoted to a subordinate state and symbolic of the saint overcoming her own misfortunes.

Although these women are within the same panel, they do not seem to interact. Each holds her own space, isolated in her individual plight. It could be assumed that these women were selected for their acts of bravery in the face of martyrdom, and indeed Rego said that *Crivelli's Garden* was 'a homage to them [the women saints], their steadfastness and courage – the way they never gave up their Faith despite being put to the rack or whatever'.[17] Yet her choice of subjects, particularly Mary Magdalene, a figure who also appears in the left panel of the work, as well as saints Margaret and Mary of Egypt, hints at another more complex aspect of redemption. That each is noted for previously leading a sinful life as a social outcast belies a feminist imperative, for these women may, as art historian Maria Manuel Lisboa described, 'be more immediately associated with examples of female evil, denounced by the Holy Church since time immemorial'.[18] Rego's inclusion of these complex women, alongside readily celebrated figures such as the Virgin Mary or St Catherine, is an act of reclaiming

their positions, not necessarily as heroines of their individual causes but by increasing their visibility within a hierarchical canon of European painting that holds religious and historical painting in highest esteem.

In 1999, Rego returned to the theme of women saints in a large pastel-on-board triptych titled *Martha, Mary, Magdalene* (fig. 4), in which she depicts the saints as young women in different cultural roles. The Virgin Mary features in a Pietá on the central panel, grasping an adult Christ as he lays balancing across her lap, her legs planted wide to accommodate his weight. The look on her face is one of uncertainty, perhaps doubt, reflecting an expression that Rego had encountered in a sculpture of the Pietá in Spain: 'I wanted to try and do something with it ... Mary looking really cross and disgusted'.[19] Framing her on either side, Martha in the left panel is here depicted as an artist working at a canvas, while her sister Mary Magdalene, now a teacher, occupies the right panel, sitting on the floor leaning against a travel case, an intellectual and explorer focusing deeply on the book in her hands.[20] Shown reflecting candidly on her maternal role, the Virgin Mary is flanked by women who are active in their own agency. Together they make complex their stereotypical roles and sanctioned duties. Rego folds herself into the narrative by complicating the character of Martha, conflating the saint's symbolic role as the dutiful devotee with that of an artist dedicated to her craft. In so doing Rego also highlights her own power to communicate the lives of these women differently. Rather than attempting to provoke sacrilegious scandal, Rego's appropriation of such biblical figures aims to subvert how they are depicted, presenting them as real women based on the artist's own experience.

The leftmost panel of *Crivelli's Garden* is the largest of the three and features women from mythical narratives found in the paintings of the Gallery's collection.

Fig. 3
The Annunciation, 1981
Acrylic and collage on canvas, 200 × 250 cm
Private collection

It is a panel that Rego restarted after struggling with its composition. On the advice of a friend, she began work on a newly stretched canvas, this time introducing the large three-tiered fountain. Mary Magdalene features again in this portion of the triptych, now sitting within her own niche. Angels are positioned around her legs, as she looks up towards the sky. On the right-hand side Judith as a young girl deposits a large object into the apron of her maid and confidante. Its shape implies the head of her victim Holofernes, hidden here to avoid the gruesomeness that is often seen in famed paintings of the subject in the Gallery's collection. Instead, Rego draws attention to Judith's anxiety and personal conflict following the treacherous crime she was destined to commit. Behind the maid's shoulder, Delilah is on all fours, creeping over the sleeping and vulnerable Samson, as if an animal stalking her prey. Stories from Ovid, such as Leda and the Swan, Bacchus and Ariadne, and Diana and Actaeon, as well as tales from *Aesop's Fables*, appear in the blue-and-white-tiled walls, on the base and within the fountain, and on the columns that separate and frame the painting. All are stories familiar from the Gallery's collection, but it is important to recognise that Rego depicts them in her own forms and figuration rather than directly repeating them.

The characters are also shaped by the women that Rego knew in her life and encountered during her residency at the Gallery. Of her models she stated, 'casting is quite important because it's part of my stimulus as a painter.'[21] While some posed for Rego in person, she also referred to photographs for their likenesses. The young woman and the baby who is being held up to play with the fountain's water are based on Rego's daughter Victoria and granddaughter Lola, while the small figures standing on the stairs in the same panel are from a photograph of Rego with her daughter Cassie. Rego also used a

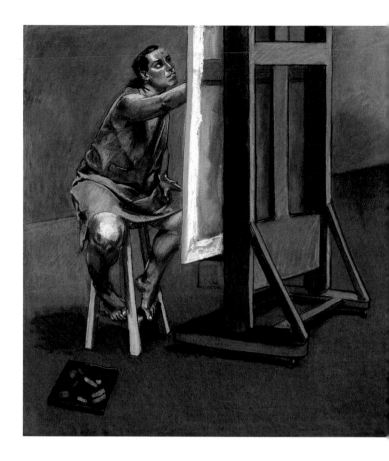

Fig. 4
Martha, Mary, Magdalene, 1999
Pastel on board on aluminium,
each panel: 130 × 120 cm
Private collection

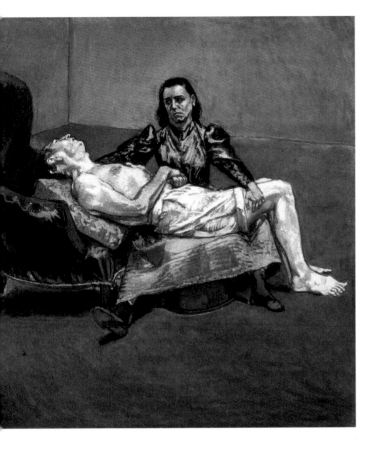
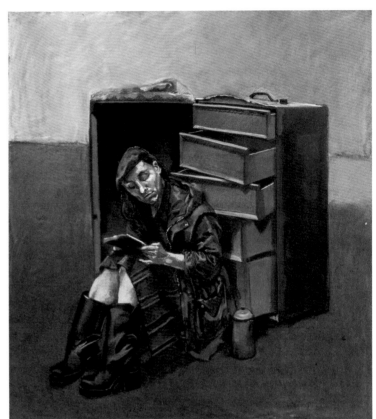

photo of her younger self for St Margaret (page 57), casting herself as the patron saint of childbirth.[22] Judith is modelled on Frankie Rossi, a member of Marlborough Gallery, which was representing Rego at that time, and the art historian Ruth Rosengarten takes the role of Mary Magdalene in the central panel.

Rego also invited members of the National Gallery's education team, whose offices were located near her studio, to sit for certain figures in the painting. Erika Langmuir (figs 9 and 10), Ailsa Bhattacharya (fig. 15) and Lizzie Perrotte (fig. 8) would end up in the final composition, after modelling for sessions that lasted an hour at a time. Rego gathered numerous drawings from these sittings, which she then redrew with more assured outlines, allowing the figuration to take form through blocks of shading, and by experimenting with the positioning of the characters' clothing, hands and heads. It was during this crucial process that Rego composed her final painting. She used various drawings as composites, experimenting with scale and juxtapositions in painted studies (figs 5–7, 19 and 20) before embarking on the larger canvases. Rego stated that 'it seemed important to use real people for these saints',[23] and she not only appropriated their likenesses but also their personalities, reflecting on her own relationships with them to inform the details that adorn their appearance or surroundings. She also responded to how they chose to position themselves while modelling, so as to shape the characters within the composition of the painting (figs 8–15).

The Mary Magdalene in the left-hand panel is modelled after Perrotte, a lecturer in the education team. Rego described this figure as, although less pensive than the older version of the central panel, a righteous scholar and a 'good witch', surrounded by the tools of her craft within her *aedicula*. She also described her

sensuality, with angels flapping between her legs to push her up towards heaven: 'I wanted the angels to come out between her legs – because you know they take her up for a meal in Heaven.'[24] Rego's Mary Magdalene here is developed further from her character in biblical narratives and is informed by Rego's sense of Perrotte's enchanting spirit within the Gallery and her broader life: 'I thought I was sitting very demurely. I remember I was always having love affairs at that time, so [Rego] was probably quite excited about that energy of me.'[25] Perrotte's casual pose is thus transformed into a fantastical version of Mary Magdalene, one that has not previously appeared in the painting canon. The biblical figure is informed by a real woman yet remains deeply rooted in fictional narrative.

Rego also makes this dynamic visible with the variety of women depicted in *Crivelli's Garden*. In among the various saints and mythological figures are groups of ordinary women, smaller in scale, wandering as if through a park full of monuments. Young girls are often accompanied by older women in activities that suggest a transference of knowledge – Rego herself stating that 'it's a picture all about stories ... about how stories and learning are passed from generation to generation.'[26] Among them, in the foreground, a young girl paints a snake, itself a loaded spiritual symbol, on a sheet of paper as an older woman watches over her. These characters were based on Bhattacharya and Langmuir, respectively junior and senior colleagues within the education team. Although they sat for Rego at different times for these figures, here their relationship within the Gallery itself – one of an experienced colleague tutoring a younger team member – is reflected in perpetuity within the painting. Bhattacharya also modelled for Rego for other figures, including the aforementioned reader sitting with her book (fig. 13) in the rightmost corner of the painting and other young women across

Clockwise from top left:

Fig. 5
Study for *Crivelli's Garden*, 1990–1
Pen, ink and watercolour on paper, 29.5 × 42 cm

Fig. 6
Study for *Crivelli's Garden*, 1990–1
Indian ink and wash on paper, 29.5 × 40.5 cm

Fig. 7
Study for *Crivelli's Garden*, 1990–1
Indian ink and wash on paper, 20.5 × 38 cm

All courtesy Ostrich Arts Ltd and Victoria Miro

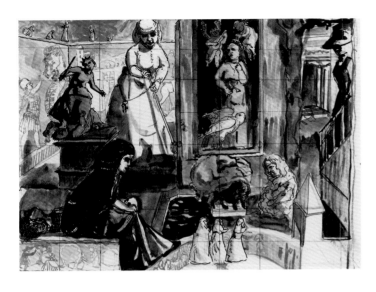

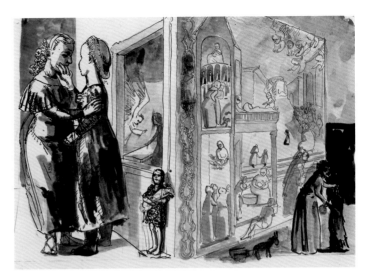

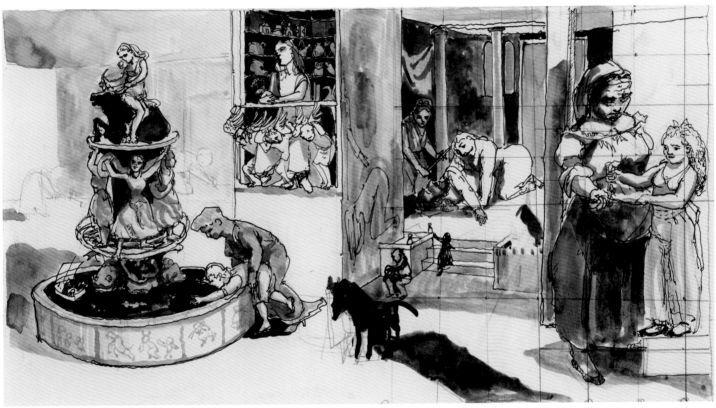

Fig. 8

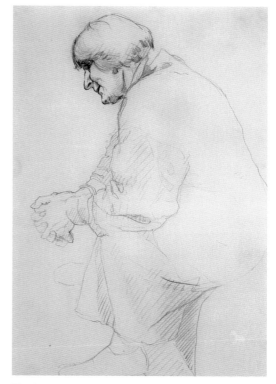

Fig. 9

Fig. 11

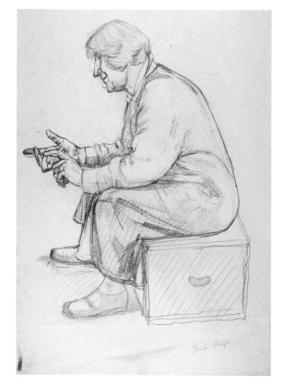

Fig. 10

Fig. 8
Study for *Crivelli's Garden, Mary Magdalene*, 1990–1
Pencil on paper,
42 × 29.7 cm
Courtesy Ostrich Arts Ltd
and Victoria Miro

Seven studies for
Crivelli's Garden, 1990–1

Figs 9, 10 and 15
Pencil on paper,
42 × 29.7 cm
Courtesy Ostrich Arts Ltd
and Victoria Miro

Fig. 11
Pencil on paper,
29.7 × 42 cm
Courtesy Ostrich Arts Ltd
and Victoria Miro

Fig. 12
Pencil on paper,
42 × 30 cm
Courtesy Ostrich Arts Ltd
and Victoria Miro

Fig. 13
Pencil on paper,
37 × 22.6 cm
Private collection

Fig. 14
Pencil on paper,
35 × 20.5 cm
Private collection

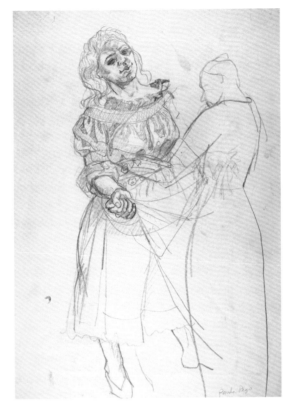

Fig. 12

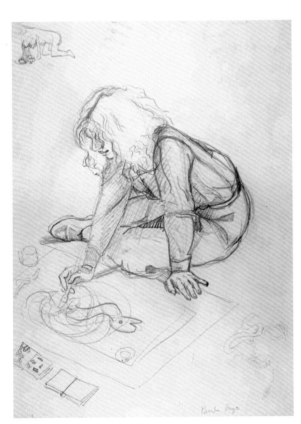

Fig. 15

Fig. 14

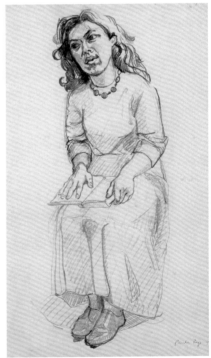

Fig. 13

the triptych (fig. 14). When she initially sat for this figure, Bhattacharya recalls how Rego asked her to pose with her hand close to her face, which evolved over further sessions to become the basis of Elizabeth in the Visitation.[27] As Rego was developing her composition for *Crivelli's Garden* through the collaborative nature of these sittings, she was continually conceiving of various moments of learning and teaching between women to populate the garden. What is significant is how she identifies the nurturing relationship between two female colleagues of different levels of seniority, within an institution that is representative of a patriarchal cultural canon and one that, like many museums and galleries, has historically been led by men. Rego recognised the need here to radicalise how the sharing of knowledge is understood and represented within the strongholds of culture more broadly.

If the purpose represented by these cross-generational meetings is the conveyance of stories, such as the exchange between Langmuir and Bhattacharya, Rego ensures that the role of painting, her own mode of storytelling, forms part of the contestation proposed in this work. It is a theme that she also invokes through other paintings made during her residency and in later works to reflect on her own position within the lineage of European painting. One of the paintings she produced for her exhibition at the National Gallery, titled *Time – Past and Present* (1990–1) (fig. 16), was influenced by Antonello da Messina's *Saint Jerome in His Study* (about 1475; NG1418) and shows an older man, Rego's friend Keith Sutton, seated in a darkened room surrounded by paintings and various objects. He is accompanied by a baby, who looks directly out at the viewer, and a young girl studiously working on a drawing, perhaps studying the man for a portrait. The man is portrayed in a contemplative juncture of his later life amidst, as St Jerome, the knowledge, memories and cultural objects he has

acquired. By including the young girl drawing in *Crivelli's Garden*, Rego complicates the preconception of cultural lineage and who holds agency in its production, an approach that Rosengarten described as being 'in opposition to the male gendering of the painter's body in the canon of Western painting, signalling the equivalence between Culture and masculinity'.[28] The young girl, as artist, now holds the power to convey how this story can be told from her perspective. Another painting made during the residency, *Joseph's Dream* (1990) (fig. 17), the subject of which is appropriated from *The Dream of Saint Joseph* (1642–3; NG6276) by Philippe de Champaigne, shows the artist now as a young woman, wearing a blue smock like the Virgin Mary, facing a large canvas on an easel. The painting in progress seems to be a new version of Champaigne's picture. A pile of sketches are gathered at the artist's feet, while the painting's eponymous subject is asleep in his armchair visible from behind the easel. Yet again, Rego subverts the usual gendered hierarchies between subject and painter as the older man, vulnerable in his slumber, is painted by a woman. The man was modelled on Rego's friend and lover, Rudi Nassauer, whose likeness is also used for the decapitated head over which St Catherine towers in *Crivelli's Garden*. For Rego to make these assertions through painting while in residency at the National Gallery is a way of flipping the narrative, to ensure that she holds authority over her place within a male lineage of painters.

This imperative comes to the fore in a satirical yet surreal painting produced a few years later, *The Artist in Her Studio* (1993) (fig. 18), in which Rego replaces the convention of a male artist surrounded by his muses and inspirations with a woman, sitting knees astride in masculine fashion, looking to one side as she smokes a pipe, itself a nod towards the transgressive nineteenth-century French novelist George

Fig. 16
Time – Past and Present, 1990–1
Acrylic on paper on canvas, 183 × 183 cm
Calouste Gulbenkian Foundation, Lisbon

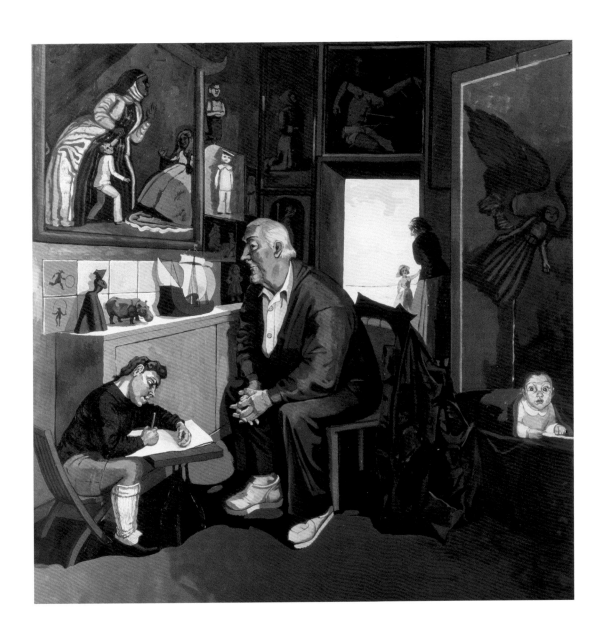

Sand, who was famed for contravening gender norms by smoking in public and dressing in men's attire.[29] The artist is surrounded by sculptures and paintings as she seems caught up in her own thoughts, ignoring the younger painter studiously working on a canvas in the lower right-hand corner of the scene, possibly of the still-life arrangement of cabbages that occupies the foreground. Rego, perhaps reflecting on her experience as Associate Artist a few years previously, acknowledges that while it is important for women to hold positions that are archetypically dominated by men, a literal reversal of hierarchy cannot be enough. Indeed, the curator Laura Stamps proposed that the painting can 'be read as a warning against a distorted notion of feminism, which does nothing to reduce inequality in the world, but merely swaps roles with the patriarchy'.[30] This emphasises the importance Rego places on intergenerational conversation and collusion between women as presented in various forms across *Crivelli's Garden*, even if it occurs at the expense of the viewer. It acts as another reminder to the onlooker of what remains unseen and untold, another of Rego's strategies for retaining power while also encouraging new narratives. The lone woman in the corner of *Crivelli's Garden* prompts her viewers to look beyond the stories hidden in her blank pages and explore narratives throughout the painting for themselves.

That the painting was produced so viewers might engage with it in this way indicates Rego's acknowledgement of the role the work would perform in the Gallery. Aware of the irony, as a woman, of her painting hanging on display in the restaurant, not on the main floor directly alongside the old masters, she revelled in the opportunities that this location might offer to engage an unsuspecting audience in an alternative space. Reflecting on how she responded to the commission, Rego said:

Fig. 17 (below)
Joseph's Dream, 1990
Acrylic on paper on canvas, 183 × 122 cm
Private collection

Fig. 18 (opposite)
The Artist in Her Studio, 1993
Acrylic on canvas, 180 × 130 cm
Leeds Museums and Galleries

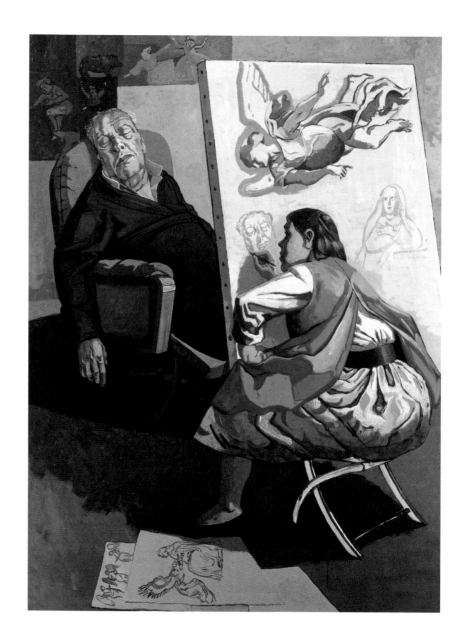

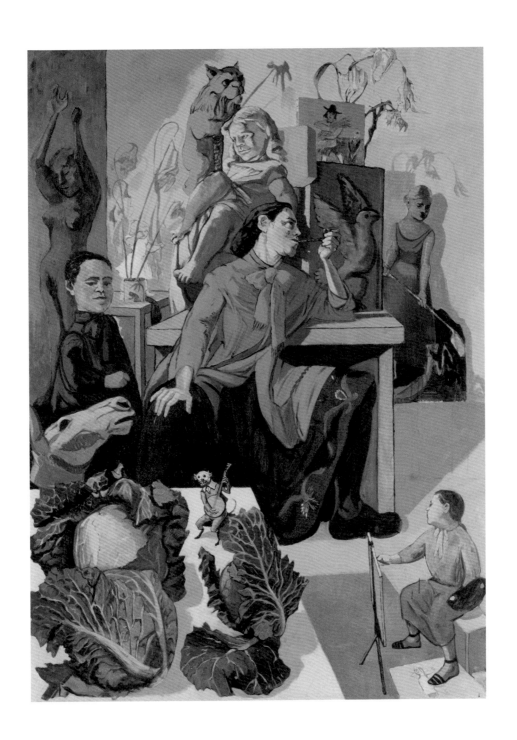

You approach it, in a way as if somebody would approach from the kitchen, so to speak, you don't go into the front door you go in the side door, right? So that makes it possible. But if you went through the front door with fanfares and everything and the waiters and everybody waiting, you come a cropper. If you go through the kitchen, you'll find a way in there you see, because that's the way in. And that's what I tried to do with the women saints.[31]

Close to the kitchen, the Dining Rooms allowed Rego to make a more pointed commentary on our shared relationship with history. Rosengarten recognised that to focus on 'the women in the background … [Rego's] work tells us, history is made possible by the invisible humdrum work – the histories – of ordinary human beings'.[32] *Crivelli's Garden* is a reminder of the esteem in which Rego held the collection's painters, their work and subjects, but also her caution of their role as monuments to the past. Many of the saintly women in the painting are portrayed as statues, in grey or brown monotone or at great scale, that are perused by the smaller figures. Although their status as static monuments is unclear, the notion of collapsing chronology into a more active and live space in which different moments of history are concurrent, as well as Rego's use of her peers as models, situates the painting in the ever present. This dialogue continues as more stories are unlocked by new visitors to the National Gallery, who are encouraged by the artist to create their own narratives for the ambiguous interactions in the painting. Understanding the enduring power of the imagination to affect change in the social realm, Rego used *Crivelli's Garden*, the most public of her commissions, as a tool to challenge how dominant histories have been told:

The telling of the story is most important, for without the story there is nothing.[33]

Fig. 19
Study for *Crivelli's Garden, The Visitation*, 1990–1
Acrylic on canvas, 80 × 100 cm
UK Government Art Collection

Fig. 20
Study for *Crivelli's Garden*, 1990
Acrylic on canvas, 80 × 100 cm
UK Government Art Collection

Fig. 21 (overleaf)
Crivelli's Garden, 1990–1
Acrylic on canvas, 189.9 × 945.3 cm
The National Gallery, London. Presented by English Estates, 1991

1. Quoted in São Paulo 1985, n.p.
2. Quoted in McEwen 1997, p. 268.
3. For further reading on Rego's reports on popular tales, see Stamps in London 2021, pp. 56–63.
4. Quoted in São Paulo 1985, n.p.
5. Rosengarten in Lisbon and London 1997, p. 43.
6. Quoted in Hastings 2017, p. 5.
7. Ibid., and unpublished author interview with Wiggins 2022.
8. Quoted in Courtney 2002–4.
9. Rosengarten 2011, p. 9.
10. See Courtney 2002–4.
11. The exhibition toured to five regional museums in 1991–2: Plymouth City Museum and Art Gallery (25 April–1 June 1991), Middlesbrough Art Gallery (15 June–20 July 1991), Whitworth Art Gallery, Manchester (3 August–25 September 1991), Cooper Art Gallery, Barnsley (22 October –30 November 1991) and the Laing Art Gallery, Newcastle (14 March–12 April 1992).
12. See Courtney 2002–4.
13. McEwen 1997, pp. 38–9, 255–6.
14. Quoted in ibid., p. 257.
15. Ibid., p. 99.
16. The identification of the figures in the painting is reliant on recorded interviews with the artist. It is important to note that these identities, particularly of the saints, may be confused in the playful skewing of iconography that Rego enjoyed with her fantastical figuration and therefore not all figures in the painting can be easily identified.
17. Quoted in McEwen 1997, p. 255.
18. Lisboa 2017, p. 107.
19. Bradley 2002, pp. 110–11.
20. Ibid.
21. Quoted in McEwen 1997, p. 261.
22. Recounted by Wiggins in an unpublished interview with the author, 2022.
23. Bradley 2002, pp. 62–3.
24. McEwen 1997, p. 267.
25. Perrotte in an unpublished interview with the author, 2022.
26. McEwen 1997, p. 268.
27. Bhattacharya in an unpublished interview with the author, 2022.
28. Rosengarten 2011, pp. 4–5.
29. For an example of artist-studio genre painting, see Gustave Courbet's *The Painter's Studio: A Real Allegory Summing Up Seven Years of My Artistic and Moral Life* (1854–5), Collection of Musée d'Orsay, Paris, against which Rego is assumed to be reacting.
30. Stamps in London 2021, p. 62.
31. Quoted in Courtney 2002–4.
32. Rosengarten 2011, p. 10.
33. Quoted in São Paulo 1985, n.p.

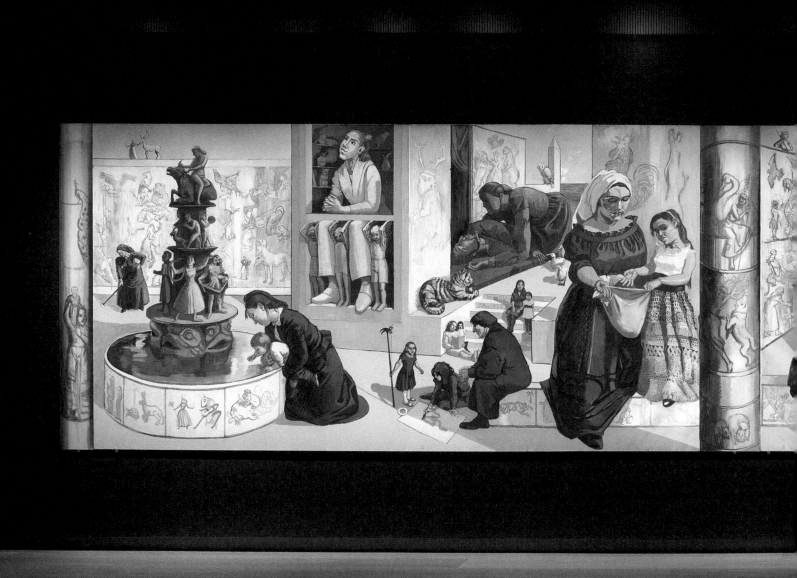

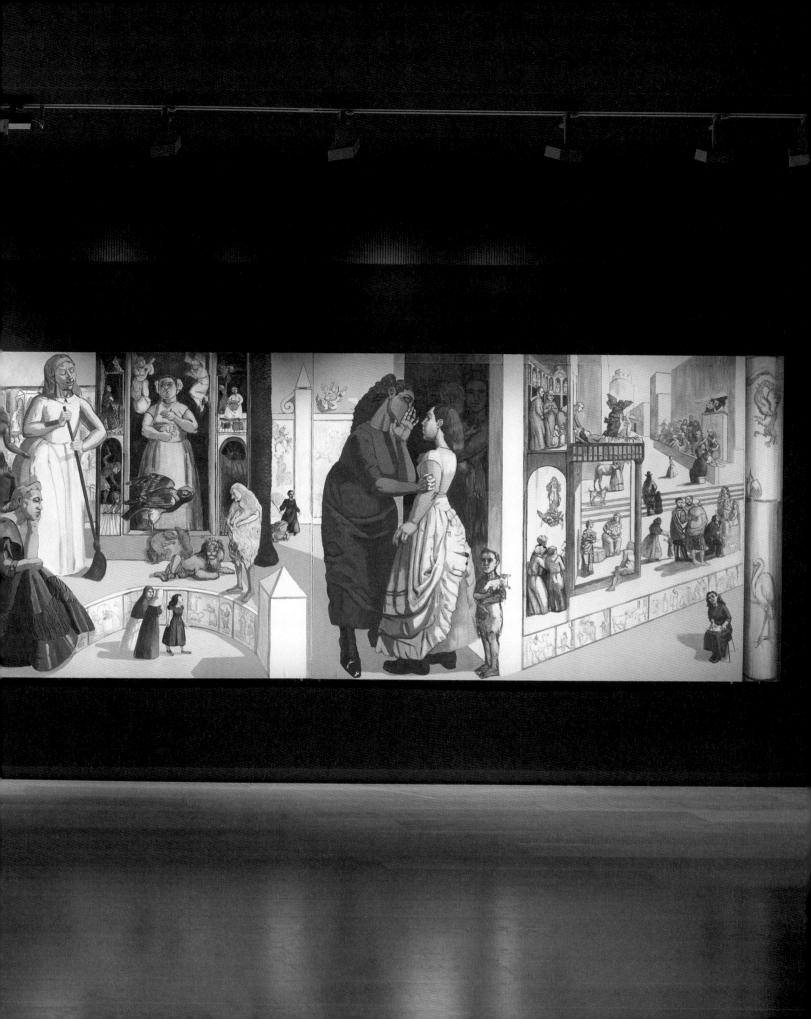

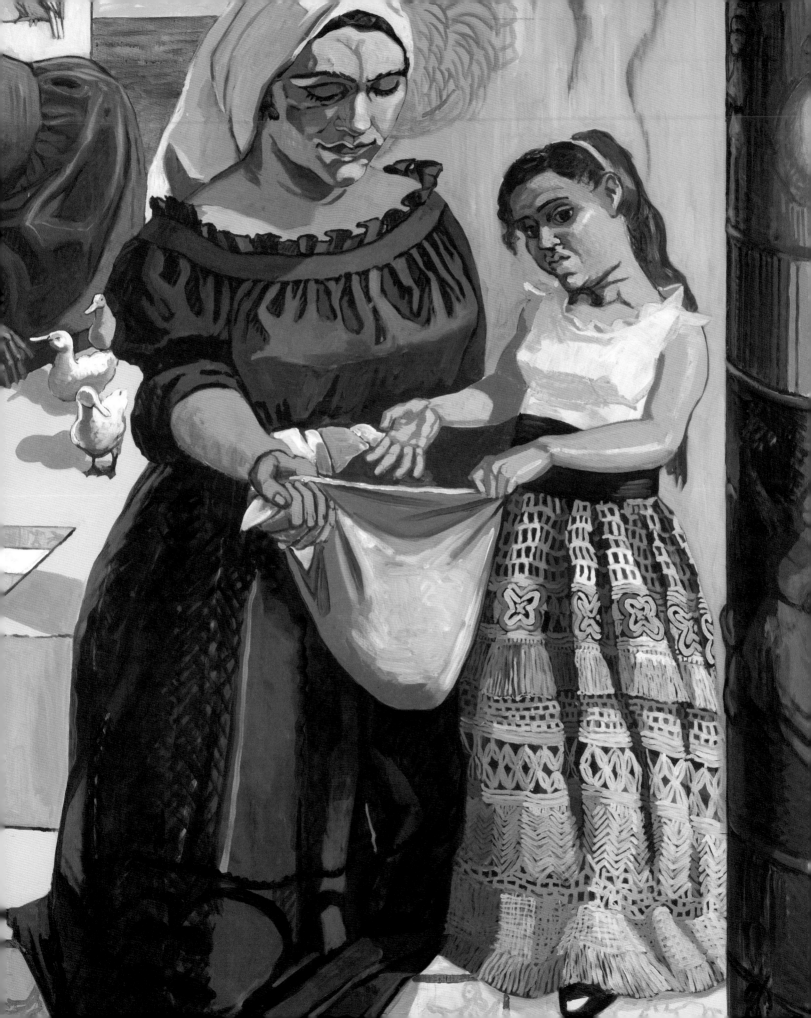

IN THE CITADEL

CHLOE ARIDJIS

An ancient silence hangs over the citadel. It has been ten days, perhaps twelve, since we arrived. The sun sows splendour and shadow and, at certain moments of the day, a stillness falls over everything, bringing most movement to a halt. Yet even the silence here bristles with life.

Garden, island, secluded citadel: this strange place is all of these things. The walls keep out conflict and enclose harmony, a harmony so hard come by, I now know, it must be preserved at all costs.

That is what we first glimpsed from the distance at dawn: a fortress of white stone, its high walls interrupted by the occasional column or path to the sea. Masses of vegetation pressed up against its edges, striving to climb up and over, an exuberant landscape pleading to enter. Yet the garden's stone and tiles remain sovereign.

In order to disembark we held conversations with the guard in the lighthouse. Tall and slender, in a grey neck-to-ankle dress, she was a lofty figure echoing her post. We had spotted the steady beam from the sea, seeming to appear only when we were looking for it, and waited until daylight to approach.

The guard descended her stone tower and addressed us from its base. As we strained over the prow of our ship, some of us to speak and others to listen, we explained we were a travelling academy. Eight women, including myself, and twelve men. There were also a few children. We taught painting, Latin and philosophy, and whatever else curious minds might be after, and had brought with us a small number of books. Since fleeing our war-torn village two years ago we had been sailing from land to land, offering instruction in exchange for provisions. But somewhere near the Strait of Magellan we had run out of supplies. Might it be possible, my father asked, for some of us to take shelter on the island while the ship searched for a port? The guard asked what the islanders would receive in return. Free lessons, my mother, the head instructor, replied, accustomed to a similar exchange wherever we went. Would we respect the quiet vows of the island, the guard then wanted to know, since its inhabitants spoke in whispers. We agreed.

By mid-afternoon, just as we were starting to lose patience and weigh anchor, she returned. Permission had been granted for us to come ashore, under one further condition: only women were welcome, and children. We agreed to this too. The men would return for us once they had found a port at which to refuel. As we wound our way up the sandy path from the shore, I turned to watch my father's figure growing smaller on the shrinking ship, which within minutes had transformed from capacious home into miniature toy.

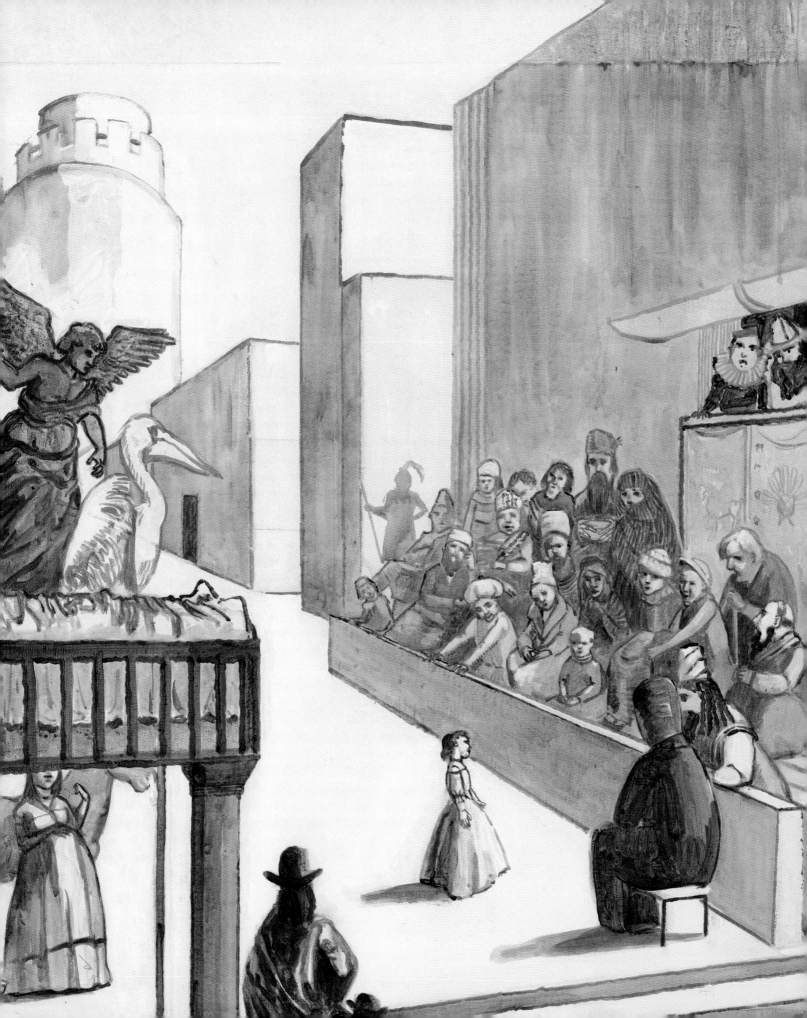

A rusty bronze lock outside the gates brought us to a halt and for several minutes we waited under the scrutiny of a white owl patterned with grey, its round face full of curiosity as it peered down from its turret. There came a sound, a jangling, as a girl in a dark blue dress appeared, wielding a set of keys. She narrowed her eyes and tilted her head as she inspected us, then said something in an old language we didn't understand and then in one more modern and familiar, and let us in.

As soon as I entered I was struck by the tranquillity of the place, its splendid stone and soothing geometry, neat angles replicated in the pinafores worn by some of the island's inhabitants, who seemed to be nearly all women. They raised their voices when addressing us and, with the cordial yet wary formality of many islanders we'd encountered, they took us to where we would sleep, a set of subterranean rooms furnished with wooden beds and tables, and pointed out the hollow in the wall where food and jugs of drinking water were kept.

Before going to bed we were taken on a brief tour of the land. By then dusk had arrived, the tropical sun casting a warm orange light, elongated shadows falling upon person, plant and beast. Evening smoothed out the angles of the garden but it also revealed its many hiding places, the deep recesses in walls and sudden bends like hands beckoning in other directions. The air, still humid, seemed to have hardly cooled, but now a sultry breeze animated the space. I felt alternately hot and chilly, and was thankful for the woollen scarf I'd brought from the ship.

As the owl asserted its reign overhead I noticed a few small creatures scampering to safety, slipping into their burrows and lairs, and the smell of tossed earth. In the distance were the utterances of the sea; in the vicinity, strange noises resembling animal calls, accompanied by a loud breathing. At one end of the garden I thought I could make out several very large silhouettes in the corners, like slumbering mounds. One of them seemed to stir when we walked past as if discomfited by our arrival.

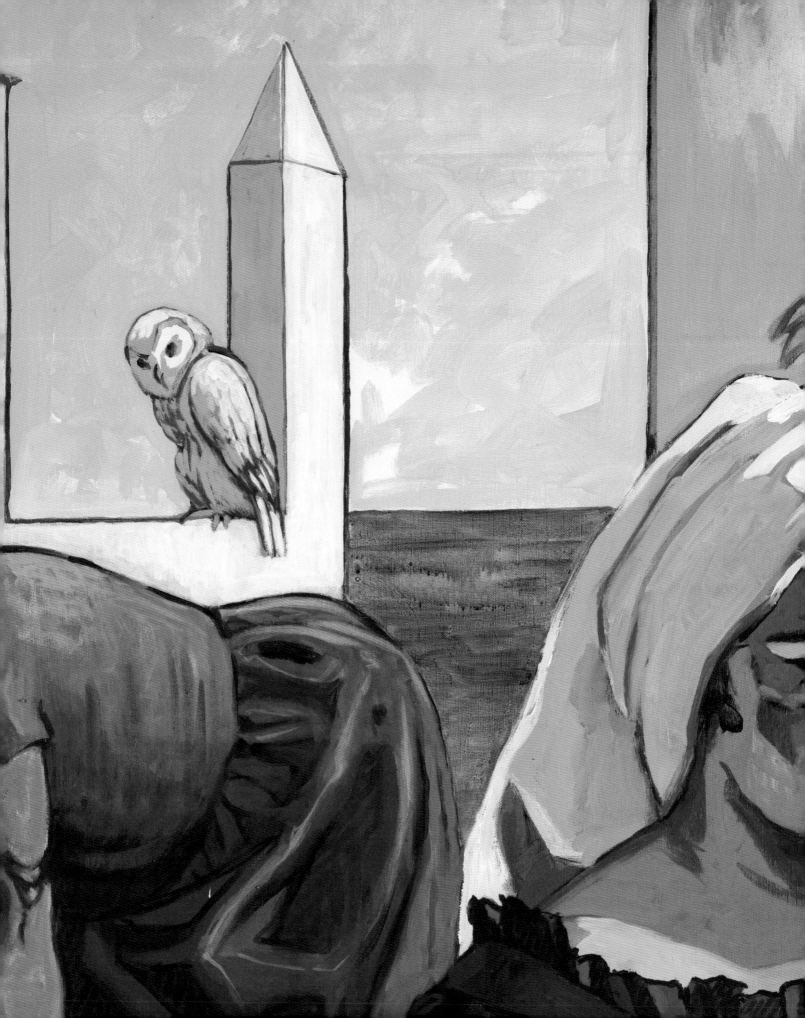

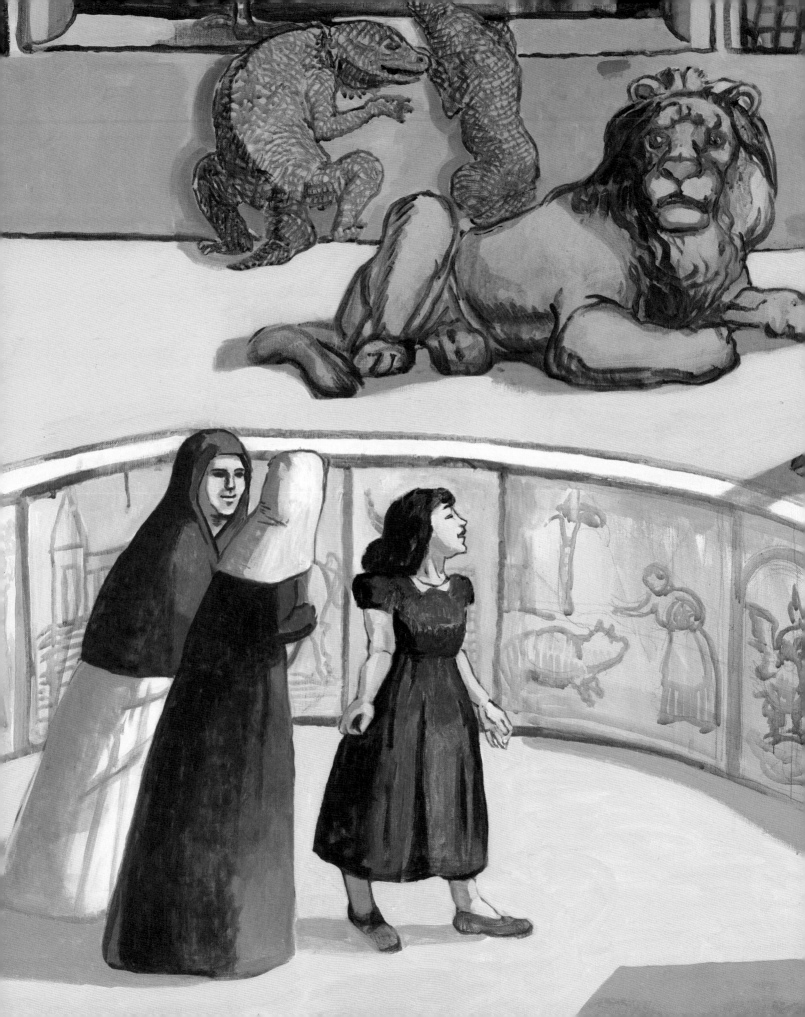

My sister and I were assigned the smallest room, my mother and the children the largest, and her teaching assistants the neighbouring chambers. It was a relief to be on land again, on land and in bed beside my sister, curled up as we used to long ago. Packed into the ship we formed one entity; ashore, we decompressed into our individual selves, my sister focused on her young son and my parents on the academy. After my mother decided I was too excitable to assist in any instruction, she gave me mundane chores to perform in the hope, she said, of taming my fiery mind. I longed for companionship, of any sort, wherever we went, yet the lessons dominated everything. Few bonds were formed apart from the tutelary. Friendships forged would soon be abandoned; the more we travelled, the more I felt I was leaving behind. Even the insects changed between the places we visited more quickly than I could register, as did the shifts in light, and night after night I'd spend hours on deck searching the sky for some sort of constancy. Solitude and longitude: it became harder and harder to distinguish between the two.

The next morning I rose earlier than the others, jolted awake by a sharp disquiet paired with an impatience to explore the land by day. Birdsong filled the air but I couldn't see any birds as I crept out into the open. Somewhere towards what felt like the centre of the island, or perhaps its most interior region, was a large fountain, similar in diameter to the fountain in our village yet much more elaborate. It had figures on every tier, with sea monsters at the base, women doing a serpent dance on the next level, then musical fauns and finally a female figurehead clutching the horns of a bull. I felt a strange attraction towards the fountain, an urge to perch on its rim and run my hand through the water, but just as I began walking towards it I sensed movement around me.

The mounds from the night before were starting to move and not only to move but to unfold, into women of monumental size who rose from the ground like giant flowers unfurling, one by one. They had thick hair and medieval shoulders, and the pleats in their dresses undulated like small mountain ranges. And once they'd reached their full height they took up different positions in the garden. The woman in white reached for a broom and began to sweep, another started to polish a pair of brown boots, while another set out bread, water and a basket of figs on a table. A colossal girl with a blue rose in her hair filled a watering can and began nourishing a patch of soil. They did this all quietly, not interacting with one another, each absorbed in the task at hand, and yet I sensed an unspoken sisterhood. As the smaller residents of the island emerged from their burrows and sat down to breakfast I couldn't help wondering whether the large women were somehow subservient to them.

My mother and her retinue surfaced from their rooms and after
a brisk greeting joined the others at the table. They were
hungry – no one had offered us food the night before – but also
impatient to justify their presence and start the lessons and,
after helping themselves to figs and bread with honey, they went
to fetch their teaching materials. As though long-acquainted
the instructors and students fell into pairs quite naturally,
one teacher per pupil or two, and while they settled into their
rhythms I wandered the island. I wasn't allowed beyond the
garden walls yet I soon discovered the garden itself seemed to
extend infinitely, and each time I thought I'd reached the end
there was a surprising twist or turn that led to another section.
I was used to the chaotic, uneven terrain of other lands; here,
the ground was so smooth, I was fearful of slipping rather than
stumbling, and felt eyes following my tentative movements.

Towering over us like thick swaying trees, the large women
continued with their tasks. Sweeping, watering, polishing.
And yet my mother and the others, occupied with their lessons,
took no notice of them. I was the only one who was intrigued,
particularly by the colossal girl now sitting in a niche, hands
clasped, gazing upwards. I admired the blue rose in her hair,
could almost feel the prick of its thorns, and longed to talk to
her, but was uncertain of what to say.

Whenever the academy arrived somewhere new I would first try
to befriend the animals. They were the ones whose movements
best explained the lie of the land, the pacts between residents,
the rituals we might expect to see. Yet the animals here were
less forthcoming. The owl kept its distance, a serious sentinel
flying from post to post as it kept watch over land and sea.
Salamanders dashed across the walls, then slipped out of view.
The ducks, initially curious and then apathetic. A lamb in the
arms of a little boy – one of the few males on the island. The
striped cat would stop, listen, pounce and carry on, at moments
gripping the silence between its paws. I pulled the ribbon from
my hair and waved it but the cat wasn't interested in playing;
it had higher motives in mind than a game of string.

Despite the activity around me – figures of all sizes moving
in and out of sight, creatures scurrying across the land, a muffled
stream of incomprehensible whispers and animal sounds –
I sensed a certain listlessness and had the urge to introduce
energy into the scene. My attention returned to the fountain.
This time I reached for an old coin at the bottom of my pocket
and dropped it in. Ever since my father had given it to me for
my twelfth birthday this silver memento from our land had
accompanied me on our travels, both past and future pinned to
its engraved quadriga, but I now felt compelled to hand it over,
almost sacrifice it, to the present.

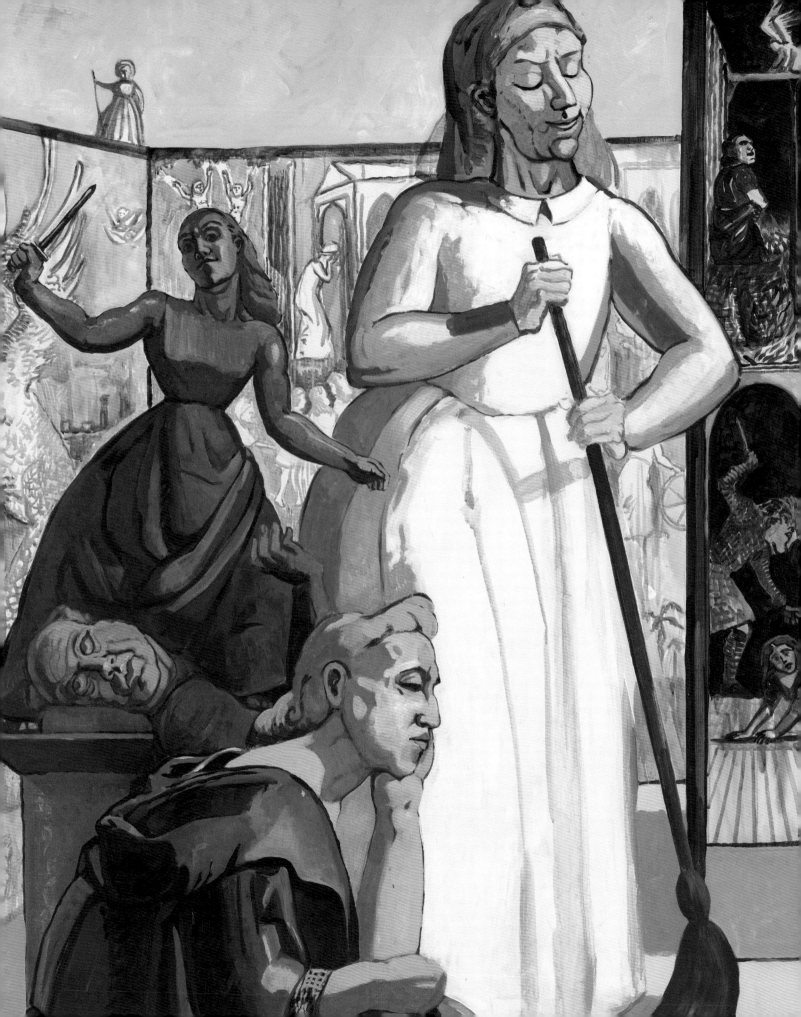

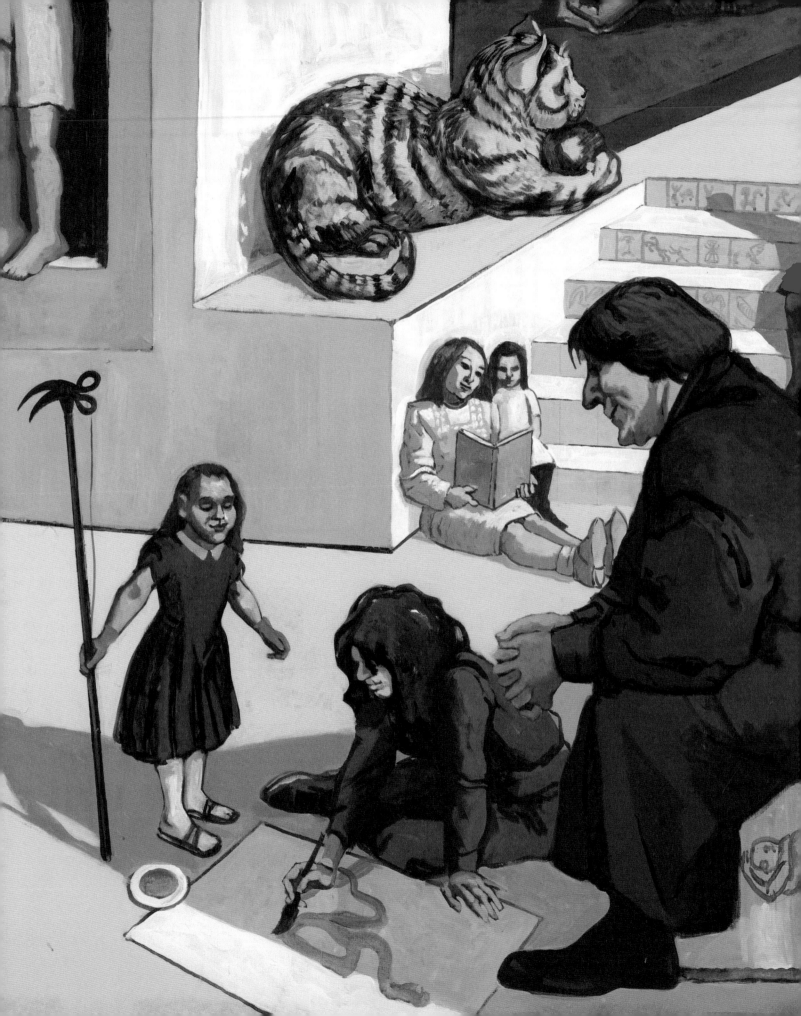

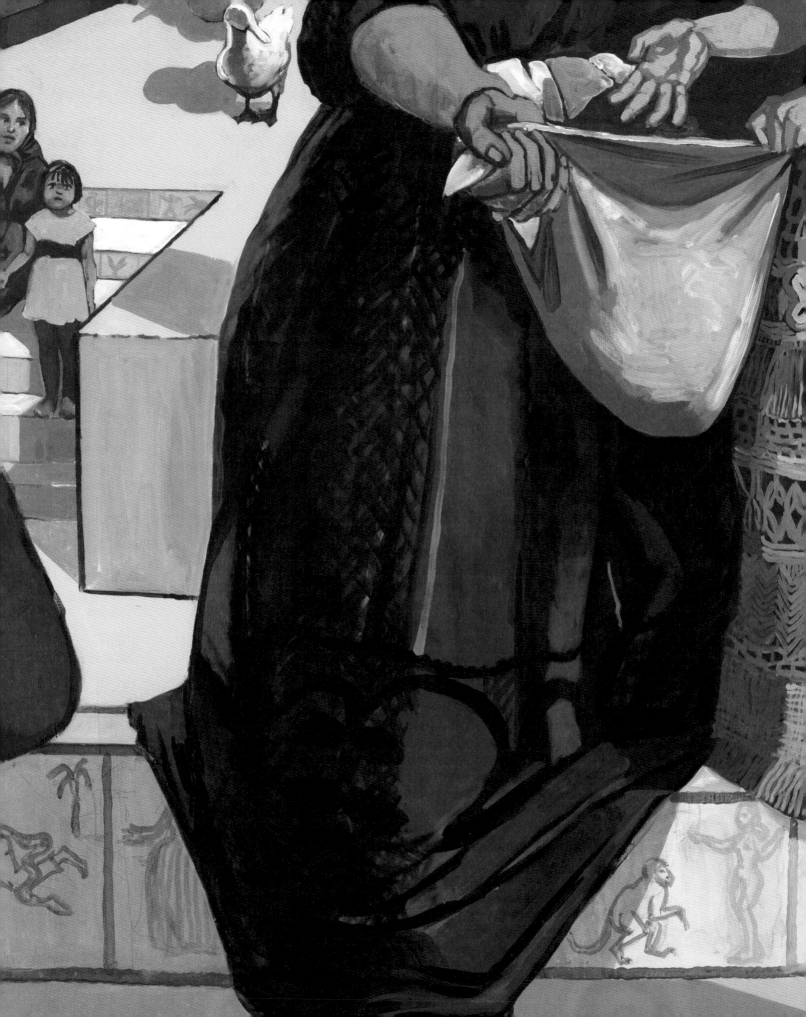

After hearing nothing I peered into the water, wondering how far down it had travelled, the fountain perhaps deeper than it looked. I expected to see the reflection of the cobalt blue sky but instead a man's face suddenly appeared beneath the surface. Bearded, with a downturned mouth and glowering eyes. He was staring up at me. It wasn't the face of anyone I knew and yet his hungry gaze, or was it despair, reminded me of a man who would follow us at a distance when we used to walk home from school. 'You mustn't do that', said a voice behind me. 'The fountain doesn't stir, and while it doesn't stir all is well. We mustn't provoke it.'

I turned and saw the girl. She had walked across and was looming over me, her figure a giant sundial casting a long angular shadow. Her forehead and nose looked slightly sunburnt but the rest of her complexion was waxy and as smooth as the tiles.

'I just wanted to make a wish', I said. 'That was my only coin.'

'What did you wish for?'

'I haven't yet decided', I said, looking around the garden rather than within myself.

She moved away from the fountain and sat down. I followed, taking a seat next to her on the step, my head reaching the height of her knee as a column of ants marched past our feet.

'I saw your boat arrive', she said to me. 'And the group of you disembark.'

I told her we were a travelling academy, a fact she seemed to know already, and asked how she herself had arrived on the island. She replied in short, truncated sentences, as if to compensate for the height from which her words travelled down to me.

The ship was heading west. A great ship said to have been carrying one thousand passengers. She and her kin were onboard. From one moment to the next the sky had darkened. The sea began to swell. The waves turned into shards of glass, the ship tilted perilously. Water gushed in and rose to their knees, their waists, their shoulders. With the first signs of trouble all the men began to panic. Yet she and her friends remained calm. They had been through so much already. But the men clutched at whatever was within sight. For in the sinking vessel they saw all their edifices and dominion perish, too. Later, she and her friends would remember the men's outstretched arms. Their desperate hands clinging to beams. And their own hands, which they had offered and then, on second thought, withdrawn.

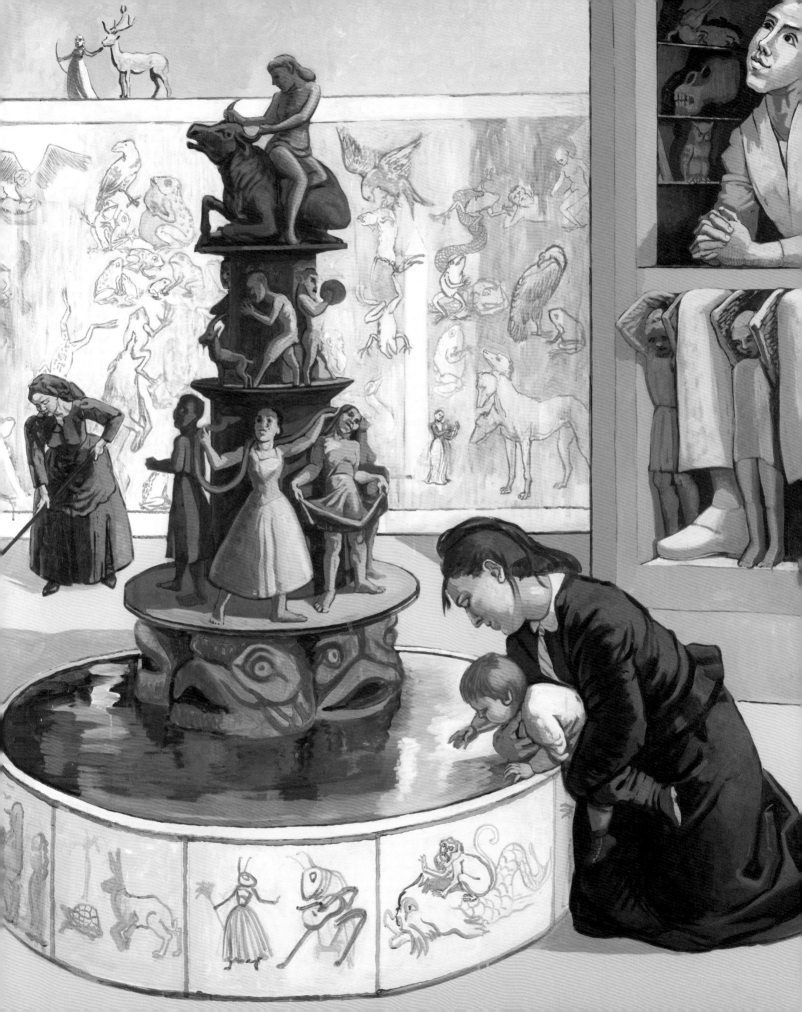

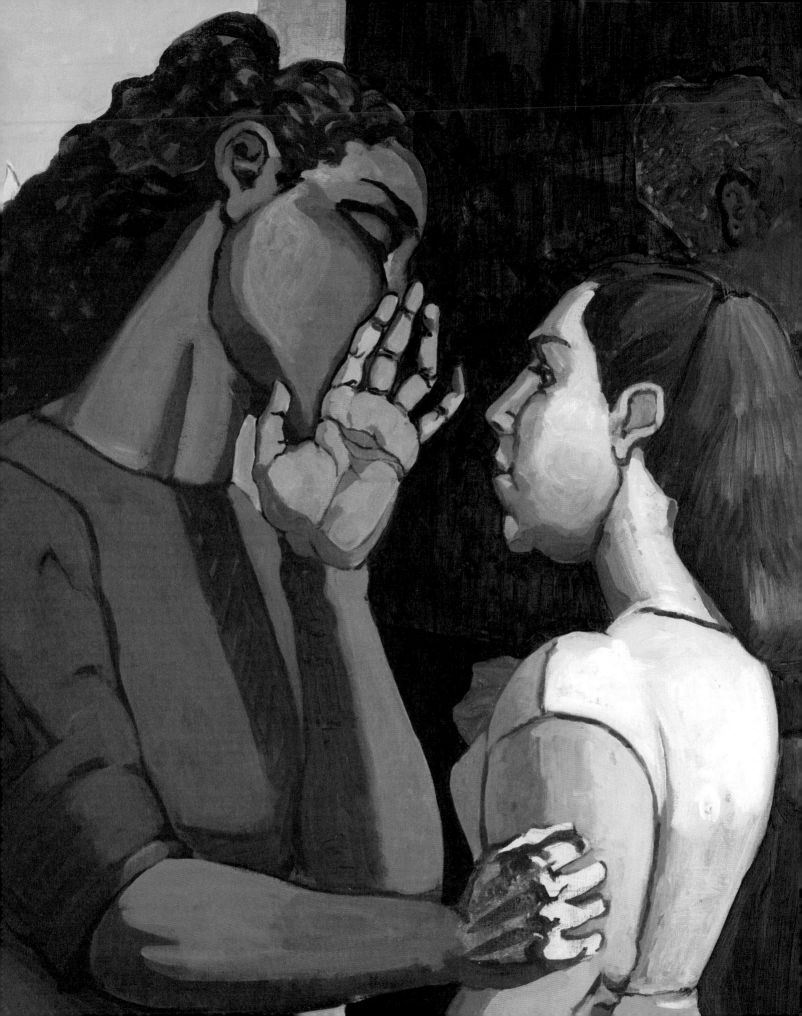

It wasn't only their calm that helped the women float. It was
their attire, bulky dresses that ballooned and then blossomed
into sea anemones as they came into contact with the water.
Dark blue, coppery brown. And they were buoyed by the waves,
until slowly their garments carried them towards the island and
guided them ashore.

As the girl spoke I turned to look at her companions in the
garden. The woman in white was still sweeping, clutching her
broom as though it were her partner in a dance of death. Another
walked past us in hurried nervous steps as if pursued by her
shadow, following her along the tiles like a hungry wolf. A third
woman of similar stature sat hunched by the wall. She seemed
to be carving something, her muscular hands holding a pocket
knife at a slant. Two others stood on a corner whispering until
one of the island's smaller residents came to tell them to stop
conspiring and return to work, although the nature of their tasks
still wasn't clear to me.

My friend leads me to the den in which I've seen her sitting,
a cool hollow in the stone, and shows me her possessions. An
alabaster ointment box, a set of keys, jars of spice, a monkey
skull and two stuffed birds. On the shelves they look dormant
but in her hands they seem on the verge of coming alive, faintly
glinting as she picks them up one at a time, then sets them back
down. This is her way of keeping her past close by, I think she's
telling me, yet safely at a distance.

She nods towards the fountain.

'When we first arrived I used to wash my hair here. It was
like a cool, transparent spring. And then one day a white stag
appeared. He dipped in his little hoof and stirred the waters.
He did so while the rest of us watched on and then left by the
same mysterious means by which he arrived. Ever since, the
contents of this fountain have changed. They harbour something
we can't identify. Our tamed water is so close to the sea, it must
hear its currents and yearn for freedom. But we don't want our
fountain to join any vastness. We want it for ourselves. And must
remain vigilant.'

I gazed up at the figure of a bull at the top of the structure, its
head twisted sideways, in the grip of a young woman astride him,
and realised how fragile the equilibrium was here in the garden,
how easily the harmony could topple.

The women seem to exist in various states of exile. Their paths
cross at different hours of the day. Yet within their composure
I sense turmoil. When one of them beats a carpet the dust smells
ancient and well travelled, as if emerging from somewhere
within her instead. When another takes a damp cloth to the walls
all sorts of figures, religious scenes and animal fables, rise to the
surface like thoughts given expression.

As opposed to the other inhabitants of the island, these women
spend all of their time above ground, unsheltered from the
elements. After days of studying them I realise they do not eat.
They do not eat, they do not drink. They do not protest. And
perhaps they never sleep. The signs all point in one direction.
These women are not mortals like the rest of us. They are saints.
Female saints who ended up on a remote tropical island and,
after so much turbulence in their lives, decided to stay.

At night I listen to their footsteps on the ground overhead:
the sound of saints pacing their heavy pasts. Once we've all
withdrawn to our subterranean chambers they set their pasts
free, let them wear themselves out a little before summoning
them back to be tamed into their daily rhythms and domesticity.
The academy doesn't understand we are already surrounded
by lessons, stories more emboldening than any sprung from a
book. Watch the women, I tell my sister one evening, and listen
to what they have to say.

I have no sense of how many days have passed. My mother,
her hair grown unruly since its last trim two islands ago, calls
me over. She hands me a paintbrush and a large sheet of paper
and tells me to join the others for the art lesson. I crouch down
beside them and begin to paint. My hand moves across the
paper as if gripped by someone else and I find myself making a
writhing blue snake, born from the same blue paint as the figures
on the walls. The pupils stare at the snake I've drawn. They now
see that each of us has the power of introducing trouble into the
garden. I feel a tingling at my fingertips. The blue in the inkwell
also matches a patch of sea in the distance, there between a
turret and the wall, the place where the island's passions
and reality meet.

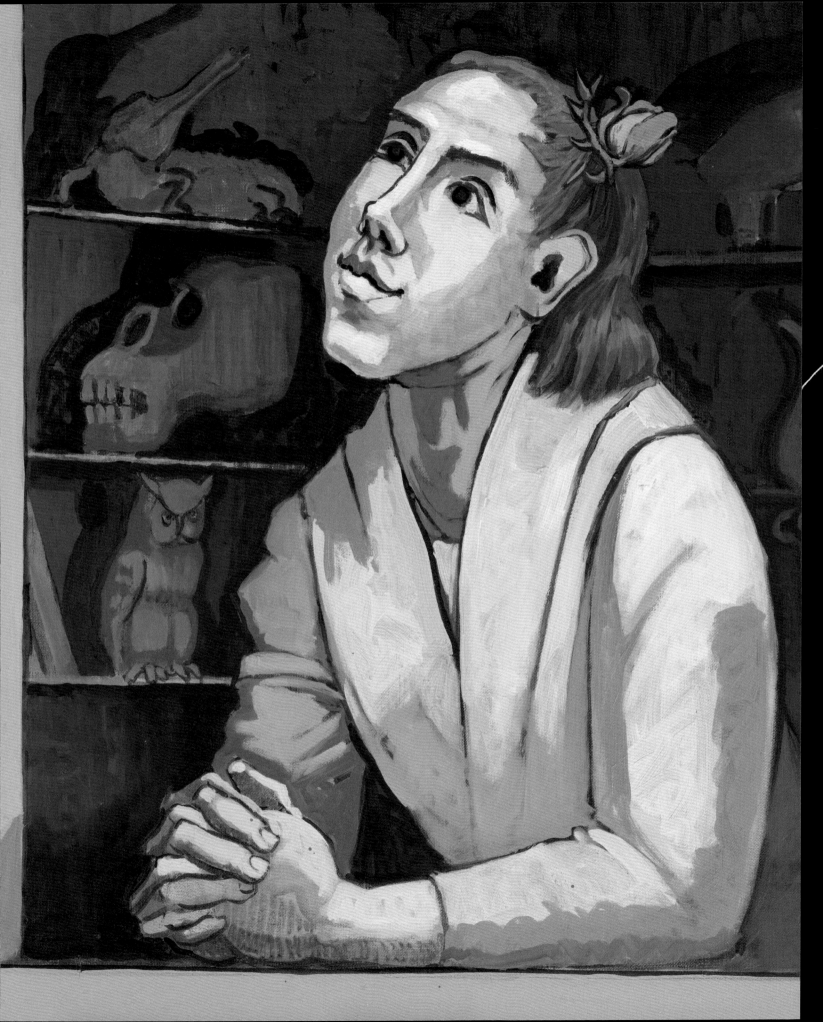

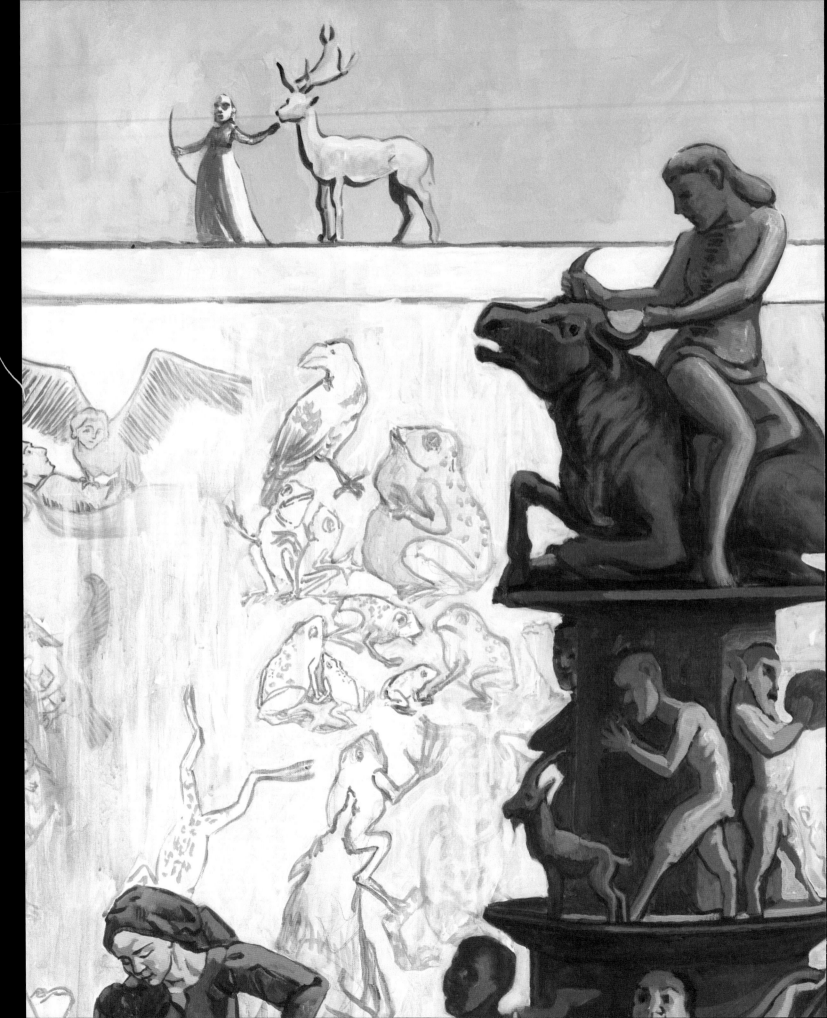

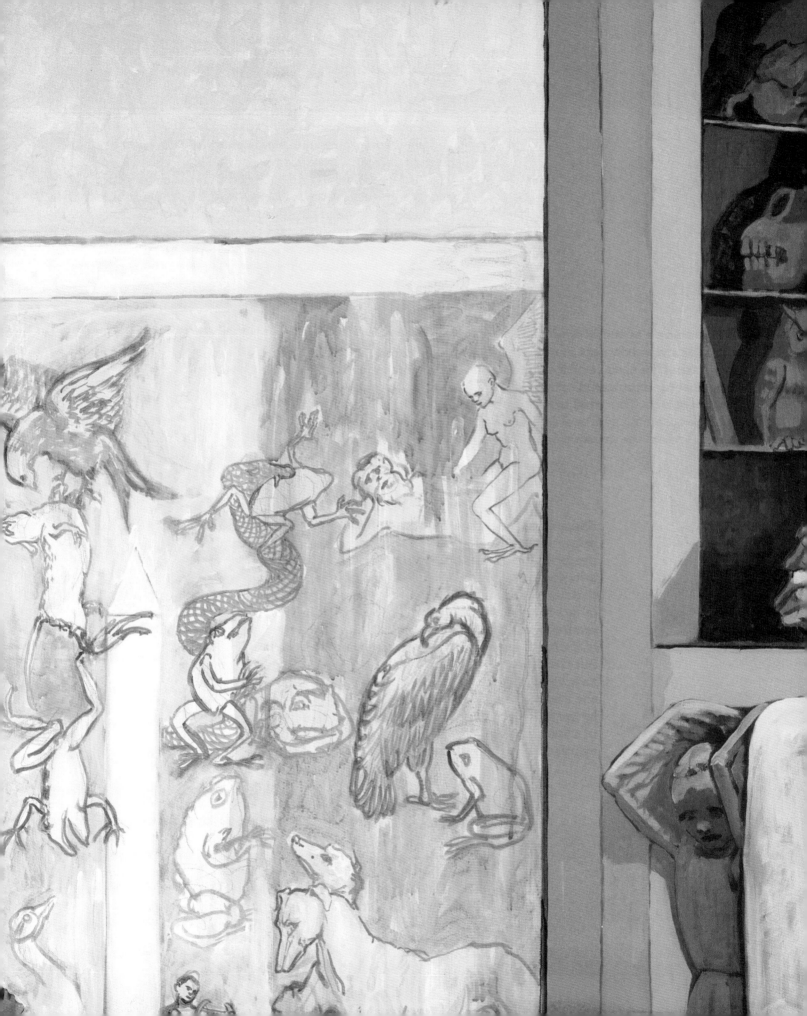

One afternoon I awake from a nap to find my sister suspending her boy over the fountain, whispering in his ear. The boy has glimpsed something in the water, his little outstretched hand clasps at a void. I hope it's my coin he has seen rather than the frightful face. There is no paper boat to sail across its surface, only the journey of his mother's voice. I warn her not to get too close, if they lean too far in they may hear the voices of drowned men from a shipwreck and perhaps even see them. She dismisses my words the way she has done so often in the past. Nearby the saints whisper, again whispering, but it's impossible to hear what they say.

That evening a powerful wind blows through the citadel, whistling around corners and howling past walls, ruffling skirts and fretting the surface of the fountain. The saints do not cower; they meet these powerful currents head-on as they break against their foreheads. This wind is nothing compared to the savagery of a desert storm, my friend tells me. By now we meet daily, to walk around the grounds or sit on one of the steps.

She points to a saint with locks of matted hair cascading to below her knees. 'She too did penance in the desert, she tells me. She too sought an unfriendly landscape after opening her own garden too often.' Yet this woman chose to bring some of that arid landscape along with her rather than leave it behind, in fact she wrapped herself in it, brambles tangled amidst other remnants of desert flora and fauna. And she refused to cut any of it off, not even one lock, insisting she would feel too exposed. But they knew it was out of penitence that she kept the long flowing hair. From the fauna that once took up residence within she has held onto a spider, a beloved pet spider who has lived by her side through many torments. She talks to her companion in a low, tender voice. Few have seen this bashful creature but everyone knows she is present.

My sister is back at the fountain, something keeps drawing her there. I can't tell whether she too feels an attraction or whether she does it to vex me. Sometimes she brings her son and sometimes she is alone, moving her hand across the water. Growing up we were often drawn to the same things – the same tree, friend, chair. She always wanted what I had, even if it was small and imaginary. I'd assumed that once with boy she would lose the urge to lay claim to whatever I had staked out for myself. But there she is, at the fountain.

'Let her be', my friend tells me when she sees my agitation. 'Let others exhaust their desires, especially when you remain in the dark as to their nature.' She goes on to tell me about a girl in a lace skirt who once appeared after a violent gale, as if brought over on the wind. Along with her maid she stood by the shore, her movements quick and furtive, hiding something bulky, somewhat spiky, in her maid's apron. When the lighthouse guard asked what she was doing the girl explained she was gathering sea urchins. The waters around the island were full of them, and in her part of the world candied sea urchins were a delicacy. No one intervened. They let her continue plucking them from the sea until she'd had her fill. As the sun began to set a boat came to collect her. Only once the girl left did they question the rounded contents of the apron, some believing it was the head of an unknown man.

My mother tells me I have become too pensive and detached, my brooding ways a bad example for her pupils. I spend far too much time with the gardener's daughter, she says, in the vicinity of the servants. I try to explain we are in the presence of something holy, much vaster than ourselves. Yet by now I know the saints have chosen to reveal themselves to me, only me, and I must honour their decision. When I tell my mother what I told my sister, that the real lessons are all around us rather than in their little books, she is furious, and sends me to sleep above ground. I find a niche near my friend and crawl into the hollowed stone. I wait for the saints, slumbering mounds around me, to start their pacing, but tonight no one shifts.

The next morning I am awakened by a loud wail. The long-haired saint's spider has disappeared. She was there only the night before, working on a web between two matted locks. The saint worries her companion has crept out of her safe place and into the garden, full of dangers: she might be stepped on, or eaten by the pensive cat or agile salamanders. She cannot imagine life, this endless afterlife, without her companion. The blue eyes in her long, sombre face weep giant tears. I can't help worrying that the spider, now free, will absorb some of the saints' formidable energy and gradually swell to monumental proportions herself. At first she may hide in a nook, then expand in the waters of the fountain, and from there she will seek a dark corner or move behind a column until one day she will no longer be able to hide behind anything and slip into view, eclipsing us with one large domed shadow.

No one else seems disturbed by the spider's absence yet I help search for it, in every niche and fissure. What are you doing, my mother asks when I peer under her dress, but before I have time to reply we hear a loud gushing behind us.

In one big agony, the fountain is giving birth. The figures have come alive, writhing round the column as the water surges upwards, so violently that the bull god is knocked from the top, and from the waters emerges a giant toad, its heavy lids blinking. It clambers onto the rim, quivering with appetite, its body puffing up before leaping down into the garden. Tense and immobile, the saints watch from their posts, aware of a dangerous energy, so carefully stored, now on the verge of release. All of a sudden my sister appears, taking determined steps towards the fountain. With a few swift movements, she restrains the toad. She strokes his slimy head and heaving haunches. The animal seems to respond to her caresses and begins to decompress. She slips a collar around his thick neck. The saints look on as the waters go still again. She has tamed something they can no longer touch.

The ship, replenished, will soon be coming for us. My friend has heard the news before I have. She will miss me, she says, but not the turbulence our academy brought to the island. The toad has been harnessed and the fountain returned to sleep but these past few days she has begun to see her older self sitting on a step nearby, her own light cotton dress traded in for heavy black and her hair gone grey. If her older self doesn't retreat once we depart, the time will come to return to the old magic. She presents me with her rose but, when I take it in my hands, it dissolves into blue dust.

As we sail off I watch her figure growing smaller, hers and those of the other saints, until they are the size of mere mortals. The lighthouse on the horizon shrinks to an unlit candle. Once the island has vanished from sight I find a quiet place on deck. I do not wish to return so quickly to our unity on board. No sooner have I sat down than a black and orange spider appears, not a particularly large spider but one that seems to carry several landscapes within her. As she creeps up my arm and settles in the warm, familiar nook between my hair and neck, I know she shall be my companion, and I hers, as the academy sails on.

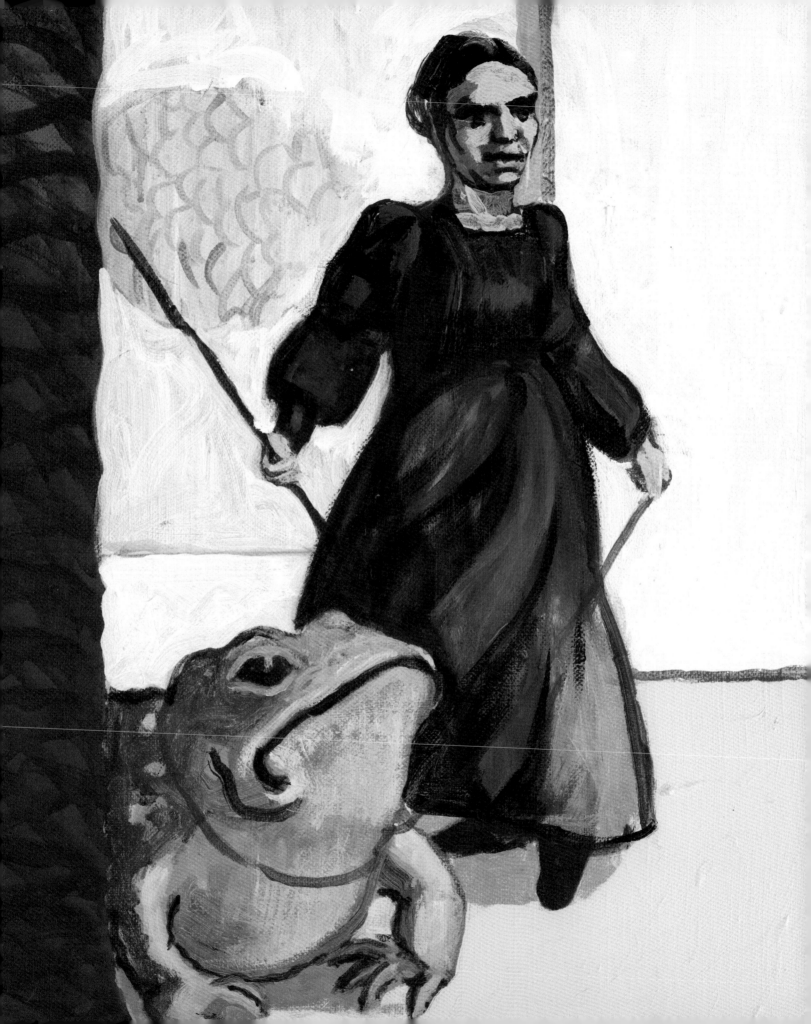

LIST OF EXHIBITED WORKS

All works by Paula Rego unless otherwise stated.

Crivelli's Garden, 1990–1
Acrylic on canvas, 189.9 × 945.3 cm
The National Gallery, London. Presented by
English Estates, 1991
H12.1–12.5, cover and fig. 21

Carlo Crivelli (about 1430/5–about 1494)
La Madonna della Rondine
(The Madonna of the Swallow), after 1490
Egg and oil on poplar, 246 × 179.5 cm (framed)
The National Gallery, London. Bought 1862
NG724.1–2, fig. 1

Study for *Crivelli's Garden*, 1990–1
Pen, ink and watercolour on paper,
29.5 × 42 cm
Courtesy Ostrich Arts Ltd and Victoria Miro
Fig. 5

Study for *Crivelli's Garden*, 1990–1
Indian ink and wash on paper,
29.5 × 40.5 cm
Courtesy Ostrich Arts Ltd and Victoria Miro
Fig. 6

Study for *Crivelli's Garden*, 1990–1
Indian ink and wash on paper,
20.5 × 38 cm
Courtesy Ostrich Arts Ltd and Victoria Miro
Fig. 7

Study for *Crivelli's Garden, Mary Magdalene*,
1990–1
Pencil on paper, 42 × 29.7 cm
Courtesy Ostrich Arts Ltd and Victoria Miro
Fig. 8

Study for *Crivelli's Garden*, 1990–1
Pencil on paper, 42 × 29.7 cm
Courtesy Ostrich Arts Ltd and Victoria Miro
Fig. 9

Study for *Crivelli's Garden*, 1990–1
Pencil on paper, 42 × 29.7 cm
Courtesy Ostrich Arts Ltd and Victoria Miro
Fig. 10

Study for *Crivelli's Garden*, 1990–1
Pencil on paper, 29.7 × 42 cm
Courtesy Ostrich Arts Ltd and Victoria Miro
Fig. 11

Study for *Crivelli's Garden*, 1990–1
Pencil on paper, 42 × 30 cm
Courtesy Ostrich Arts Ltd and Victoria Miro
Fig. 12

Study for *Crivelli's Garden*, 1990–1
Pencil on paper, 37 × 22.6 cm
Private collection
Fig. 13

Study for *Crivelli's Garden*, 1990–1
Pencil on paper, 35 × 20.5 cm
Private collection
Fig. 14

Study for *Crivelli's Garden*, 1990–1
Pencil on paper, 42 × 29.7 cm
Courtesy Ostrich Arts Ltd and Victoria Miro
Fig. 15

Study for *Crivelli's Garden, The Visitation*, 1990–1
Acrylic on canvas, 80 × 100 cm
UK Government Art Collection
Fig. 19

LENDERS

Ostrich Arts Ltd and Victoria Miro
UK Government Art Collection
Private collection

SELECTED BIBLIOGRAPHY

PUBLICATIONS

Barker 1991
L. Barker, 'Crivelli's Secret Garden by Paula Rego',
unpublished essay held in the National Gallery
Archive, London 1991

Bradley 2002
F. Bradley, *Paula Rego*, London 2002

Bristol, Milan and London 1983
Paula Rego: Paintings 1982–83, exh. cat., Arnolfini
Gallery, Bristol, 1983; Studio Marconi, Milan, 1983;
Edward Totah Gallery, London 1984, with text by
V. Willing

Hastings 2017
*Paula Rego: The Boy Who Loved the Sea and
Other Stories*, exh. cat., Jerwood Gallery, Hastings
2017, with texts by C. Wiggins, E. Gilmore and
N. Willing

Lisboa 2017
M.M. Lisboa, *Paula Rego's Map of Memory:
National and Sexual Politics*, Abingdon-on-
Thames 2017

Liverpool and Lisbon 1997
Paula Rego, exh. cat., Tate Liverpool; Centro
Cultural de Belém, Lisbon, London 1997, with texts
by F. Bradley, V. Willing, R. Rosengarten and J. Collins

London 1988
Paula Rego, exh. cat., Serpentine Gallery, London
1988, with texts by V. Willing and R. Rosengarten;
and P. Rego in conversation with J. McEwen

London 1991
Paula Rego: Tales from the National Gallery,
exh. cat., National Gallery, London 1991, with texts
by C. Wiggins and G. Greer

London 2003
T.G. Rosenthal, *Paula Rego: The Complete
Graphic Work*, London 2003

London 2021
E. Crippa (ed.), *Paula Rego*, exh. cat., Tate,
London 2021, with texts by E. Crippa, Z. Flašková,
M.M. Lisboa, M.M. Ede, G. Smith, L. Stamps
and M. Warner

McEwen 1997
J. McEwen, *Paula Rego*, London 1993 (second
edn 1997)

Milton Keynes, Edinburgh and Dublin 2019–21
A. Spira and C. Lampert (eds), *Paula Rego:
Obedience and Defiance*, exh. cat., MK Gallery,
Milton Keynes, 2019; Scottish National Gallery
of Modern Art, Edinburgh 2019–20; Irish Museum
of Modern Art, Dublin 2020–1, with texts by
C. Lampert and K. Zambreno

Porto 2004
Paula Rego, exh. cat., Museu de Arte
Contemporânea de Serralves, Porto 2004, with texts
by J. Fernandes, R. Rosengarten and M. Livingstone

Rees-Jones 2019
D. Rees-Jones, *Paula Rego: The Art of Story*,
London 2019

Rosengarten 2011
R. Rosengarten, *Love and Authority in the Work
of Paula Rego: Narrating the Family Romance*,
Manchester 2011

São Paulo 1985
*18a. Bienal de São Paulo: Stuart Brisley, Patrick
Caulfield, John Davies, Paula Rego*, exh. bklt, with
texts by J. McEwen, N. Wadley and exhibited artists,
British Council 1985

Voragine 1993
J. de Voragine, *The Golden Legend: Readings on
the Saints*, trans. W.G. Ryan, vols 1–2, Princeton 1993

AUDIO AND VIDEO SOURCES

Courtney 2002–4
P. Rego, audio interview with C. Courtney, 'Artists'
Lives', 2002–4, British Library, London

Kharibian 2011
P. Rego in conversation with L. Kharibian, The
National Gallery Podcast, Episode 56, June 2011,
www.nationalgallery.org.uk/podcast/podcasts/
the-national-gallery-podcast-episode-56
(accessed 17 November 2022)

Lambirth 1990
P. Rego, audio interview with A. Lambirth, 'Paula
Rego on the National Gallery', 31 December 1990,
British Library, London

Rego 2017
'Paula Rego – My Commission for "Crivelli's Garden"
at the National Gallery', 18 September 2017,
www.youtube.com/watch?v=Sf42-n7pSzI
(accessed 17 November 2022)

IMAGE CREDITS

ACKNOWLEDGEMENTS

The curator, Priyesh Mistry, would like to thank
Nick Willing and Paula Rego's family for their
support and enthusiasm for the exhibition from
the very beginning of the project. Ex-members
of National Gallery staff, Colin Wiggins, Ailsa
Bhattacharya and Lizzie Perrotte, were invaluable
for their time and generosity in sharing recollections
of the Gallery during the period of Rego's residency,
bringing the story of *Crivelli's Garden* to life. The
exhibition, catalogue and associated programme
have been made possible through the devotion of
colleagues and their creative collaborations: George
Bird, Neil Evans, Anne Fay, Anna Godfrey, Stephen
Guest, Charlotte Hampshaw, Jane Hyne, Joseph
Kendra, Laura Lappin, Laura Llewellyn, Katherine
Miller, Belinda Philpot, Nicola Smith, Rebecca
Thornton and the Art Handling team. Finally, the
curator shares his gratefulness to all those who
continue to be inspired by Rego and celebrate her
monumental work. In particular, Melanie Mues, for
producing the wonderful design of this book, and
Chloe Aridjis, whose insights in conversation and
enchanting short story have opened a whole new
world within *Crivelli's Garden* for readers and
audiences to enjoy.

Published to accompany

Paula Rego: Crivelli's Garden
The National Gallery, London
20 July – 29 October 2023

The H J Hyams Exhibition Programme
Supported by The Capricorn Foundation

The Leading Philanthropic Supporter of the
National Gallery Modern and Contemporary
Programme is

 SP LOHIA FOUNDATION

The Contemporary Programme is sponsored by

Contemporary Art Partner
of the National Gallery

This exhibition has been made possible by the
provision of insurance through the Government
Indemnity Scheme. The National Gallery would
like to thank HM Government for providing
Government Indemnity and the Department for
Digital, Culture, Media and Sport and Arts Council
England for arranging the indemnity.

First published in 2023 by
National Gallery Global Limited
Trafalgar Square
London WC2N 5DN
www.shop.nationalgallery.org.uk

ISBN: 978-1-85709-696-5
Product code: 1051517

British Library Cataloguing-in-Publication Data.
A catalogue record is available from the British
Library. Library of Congress Control Number:
2023931208

Publisher: Laura Lappin
Project Editor: Anna Godfrey
Copy-editor: Blanche Craig
Proofreaders: Linda Schofield and Bridget Harley
Picture Researcher: Rebecca Thornton
Production: Jane Hyne
Designed by Melanie Mues, Mues Design, London
Origination by ALTA, London
Printed in Belgium by Graphius

All works are by Paula Rego unless
otherwise stated. All measurements
given height before width.

Cover: *Crivelli's Garden*, 1990–1
Acrylic on canvas, 189.9 × 945.3 cm
The National Gallery, London
Presented by English Estates, 1991

MIX
Paper | Supporting
responsible forestry
FSC® C014767